pet photography

now!

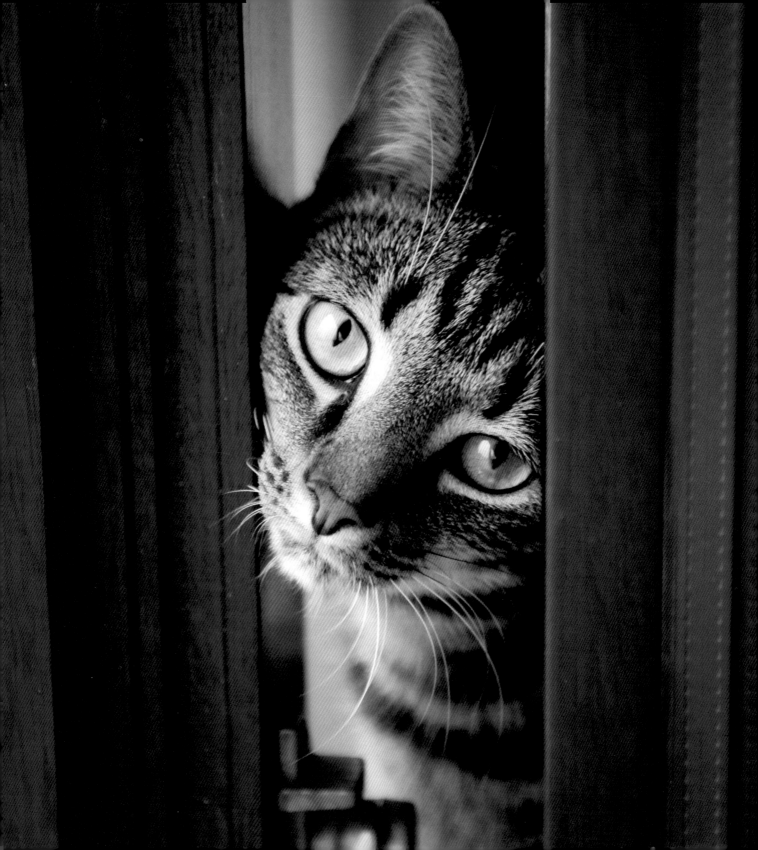

pet photography now!

a fresh approach to
photographing animal
companions

Paul Walker

LARK BOOKS

A Division of Sterling Publishing Co., Inc.
New York / London

Pet Photography NOW!
A Fresh Approach to Photographing Animal Companions

Library of Congress Cataloging-in-Publication Data

Walker, Paul G., 1972-
 Pet photography NOW! / Paul G. Walker. -- 1st ed.
 p. cm.
 Includes index.
 ISBN 978-1-60059-208-9 (PB-with flaps : alk. paper)
 1. Photography of animals. 2. Pets--Pictorial works. I. Title.
 TR727.W25 2008
 779'.32--dc22
 2008015979

10 9 8 7 6 5 4 3 2 1
First Edition

Published by Lark Books, A Division of
Sterling Publishing Co., Inc.
387 Park Avenue South, New York, N.Y. 10016

© The Ilex Press Limited 2008

This book was conceived, designed, and produced by:
ILEX, Cambridge, England

Distributed in Canada by Sterling Publishing,
c/o Canadian Manda Group, 165 Dufferin Street
Toronto, Ontario, Canada M6K 3H6

If you have questions or comments about this book, please contact:
Lark Books
67 Broadway
Asheville, NC 28801
(828) 253-0467

Manufactured in China

ISBN 13: 978-1-60059-208-9

For more information on Pet Photography NOW! see:
http://www.web-linked.com/pnowus

For information about custom editions, special sales, premium and
corporate purchases, please contact Sterling Special Sales Department
at 800-805-5489 or specialsales@sterlingpub.com.

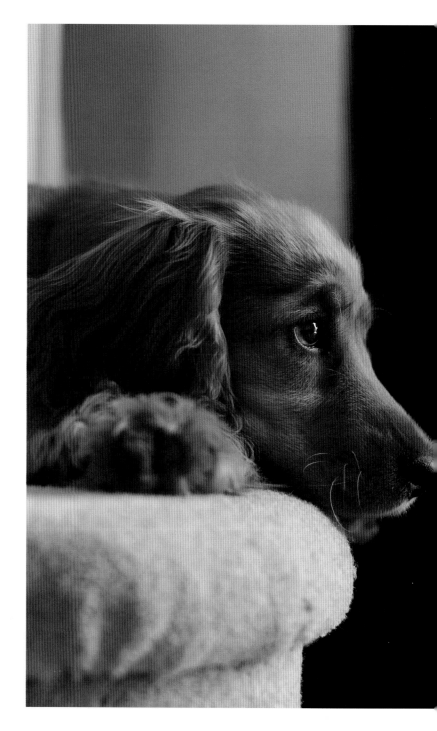

Contents

\mathcal{I}ntroduction 6

\mathcal{T}he Essentials 8

Cameras & lenses 10
Lens choice 14
Computers and other hardware 16
Lighting 18
Bag of tricks 20
Sets & props 22
Preparatory homework 24
Timing the photography 28
Pet owner 30
Pet grooming 32
Safety & welfare 34

\mathcal{S}hooting 36

On arrival 38
Choice of environment 40
The pet 44
Three classes 48
Photographing pets 50
Handler's rules 56
Pet photography styles 58
Use of artificial lighting 62
Camera angles for pet portraiture 64
Lighting angles for pet portraiture 66

\mathcal{P}ets in Detail 68

Puppy portraits 70
Dog portraits 72
Leash holding techniques 74
Guidelines for improved dog portraits 76
Taking the photograph 78
Dogs in action 80
Predominantly white or black coats 84
Dog group portraits 86
Dog group portrait tactics 88
Kittens 90
Kitten strategies 92
Cat portraits 94
Cats in action 98
Cat groups 100
Small furry pets 102
Horses and ponies 104
Birds of a feather 106

\mathcal{P}ost Production 108

Digital output 110
Getting set up 112
Workflow 114
Physical display options 120
Digital display 122

Top 10 Tips 124
Index 125
Acknowledgments & Useful Websites 128

Introduction

A well trained, obedient Border Collie is extremely responsive to its handler's commands and lives near rolling, scenic hills, open countryside, and a beach. There is good natural light and the dog behaves well in the presence of young children, other dogs, horses, and livestock. Are you ready to take some photographs? You bet.

A dark colored rescue dog awaits you in a small, inaccessible apartment. It is in need of being groomed. Space is limited and the only natural illumination comes from a small window. The dog has recently been rehomed and is disinclined to trust strangers, so rarely stays still. The ageing furnishings and garishly patterned wallpaper in the apartment have also seen better days. Are you still ready for the challenge?

Pet Photography Now takes a "mindset approach" to the often challenging area of pet photography. Over the following pages I am to equip you, the photographer, with some of the vital skills and thought processes necessary to taking great animal portraits.

Digital cameras provide more chance to learn the technical aspects of taking pet pictures.

Personally I have spent much of my life talking to animals, mostly cats, dogs, and the occasional guinea pig. The experience of always being surrounded by animals certainly provided me with a good grounding in pet behavior, as I'm sure it will have for you if you've picked up this book. As a professional photographer it seemed natural that I should turn my love of pets—whether they are dogs, cats, rabbits, or any other exotic animal that might live in someone's home—into a career. It's been great fun so far and with the arrival of digital technology things are getting better and better.

Too often in the past we have excitedly returned from picking up our prints only to see blurry, unrecognizable images or half cropped heads of our beloved pet. New technology takes away the wait, but the same mistakes and errors of judgement are there to be potentially made again and again. Instead, though, we can use the immediate feedback of the camera's LCD to check our results and see where we need to make changes. To help us achieve this we can access a wealth of image data that is simultaneously captured the moment the shutter button is pressed, including the shutter speed, aperture, ISO settings, and others that we might simply not had time to check when capturing the shot.

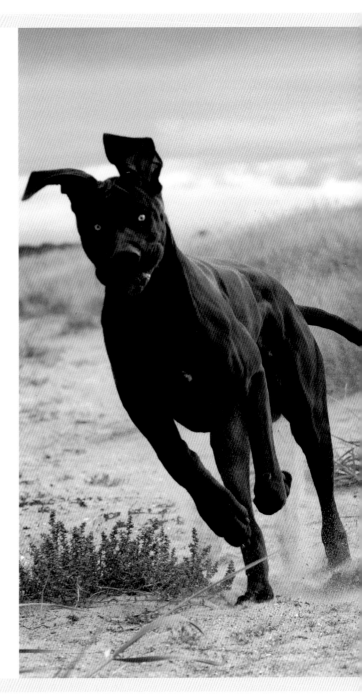

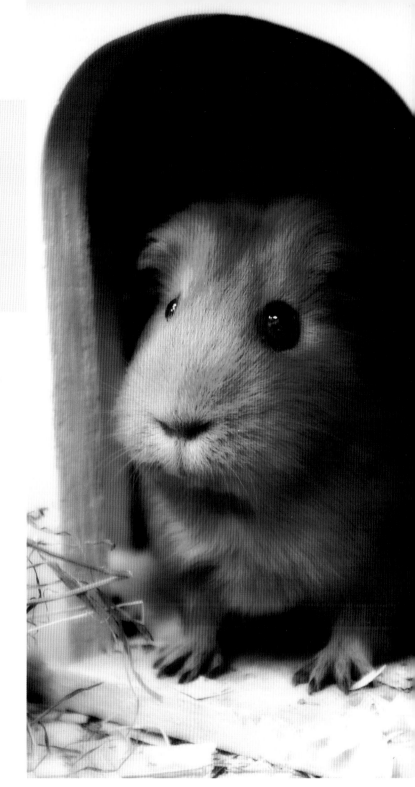

As with other areas of photography there are infinite strategies and techniques used by photographers to produce stunning pet portraits, from simple head and shoulder images through to wide-angled scenes depicting the movement of a whole pack. It would be impossible to discuss every conceivable scenario in any book, but what you will find within these pages are the transferable skills and the right mental approach that you can apply to any situation. There is something here for you whether you're a hobbyist, amateur, or professional entering this new market; after all, the distinction will be lost on your subject.

For simplicity, the book is divided into three key sections. The first aims to cover all the necessary ingredients to planning a successful photo shoot. Everything before the point of actually picking up the camera. It details the necessary photographic equipment, props, and items that can help you plan your photography session, capture the desired results and oversee the safety and welfare of any pet. It is important not to underestimate the benefit of advance planning when shooting pets. It will certainly maximize your chances of securing memorable images.

In the second section of the book, various strategies will be explored for photographing dogs, cats, and other common pets, both outdoors and in indoor environments. The accompanying images will provide full camera data detailing the settings chosen. This section will also provide guidance on scenarios for photographing more than one pet at a time, for example groups of dogs or cats.

The final section of the book will outline the possibilities of digital post production, from simple tweaks to more intensely worked images manipulated in applications like Photoshop. This is rounded up with a quick look at the display options for your pet portraits; from simple frames, through to more elaborate and contemporary products to hang on your—or your client's—wall.

A little time spent planning before any photoshoot, especially—where pets are concerned—can ensure that you are well equipped for the photography ahead, both technically and mentally. Key questions need to be answered in advance to ensure that you have a good knowledge of the subject, the camera equipment necessary, and the location options available. In my early pet photography encounters, I would frequently arrive on location only to discover that I'd left a prop behind or some other camera accessory that may been useful during the shoot. If you follow the advice in these pages, you should avoid similar embarrassment, and return with the pet and its handler in top condition and the best possible results on your memory card.

he essentials

Cameras & lenses

It is frequently said that it is possible to take great images with any camera, given the right circumstances. Similarly, it is also often said that technique and creative vision will always be more important than the latest camera with whatever new feature is grabbing the headlines. Both statements are true, but another is often left out: You'll never get good results without a good knowledge of your camera's capabilities, and being fully aware of your equipment's strengths and limitations under various lighting conditions or scenarios.

For example, one camera may perform better than another in low light. Another camera may exhibit faster focusing qualities enabling easier tracking of moving animals. When you bring different lenses into play, new sets of strengths and weaknesses become apparent. Unless you are using a compact camera, your lens choice will probably be the key to "nailing" the shot. The camera and lens combination may depict the kind of images that are most favorable with such a combination, for example close-up macro images, a sleeping tortoise, or running dogs in the distance. If you have a close-up style, the longer zooms that are often touted as "key selling features" of some cameras and lenses will mean nothing to you. For example, your preferred kind of pet photography may be facial detail shots of larger pets, perhaps negating the need for one of the longer zoom necessary with running dogs outside.

The scope of the following sections is not to highlight the strengths and weaknesses of various cameras but rather to provide some guidance on what to consider when selecting the equipment for good photography.

COMPACT AND DIGITAL SLR CAMERAS

Compact cameras and digital SLR's have rapidly advanced over recent years with specifications continually improving, in terms of mega pixels, LCD size, greater integrated zoom magnifications (on compact cameras), and faster start-up times to name just a few of the many listed parameters. Many of the new specifications and features can be extremely useful on a pet photography assignment but before you make that all important purchase decision you need to consider some key features. Outlined below are some of the key features that I think are important when considering purchasing a compact camera or, if funds allow, a digital SLR. No one camera will provide you with the best of everything. It is important that you view the camera features both in isolation and collectively and consider the relative importance of them for your own circumstances and style, particularly with regard to the environment where you will be conducting the majority of your photography.

BUILD QUALITY, HANDLING & INTUITIVENESS

The build quality of camera and lenses varies greatly from compact cameras that may not withstand too many knocks, through to camera models that manufacturers claim can be dropped several feet (over a meter). Some third party suppliers also offer "tank housings," that provide a further protective shell around the camera. There are also waterproof and rainproof models available in the marketplace. It is essential to consider that size and weight

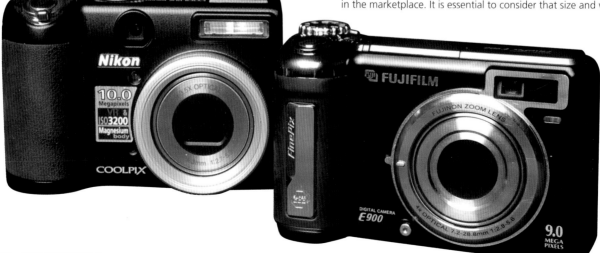

of a camera—with or without any accessories—to ensure it feels comfortable to hold in your hands, especially when moving dials or pressing button combinations while observing the scene through the viewfinder. Don't just take a friend's recommendation on handling as it is unlikely that your hands are exactly the same shape and size. If the camera feels comfortable in the hand and the buttons/menu options are easily accessible and intuitive, you will certainly have a greater chance of holding a steady camera and being able to react to changes in the scene much faster.

FOCUSING & SHUTTER LAG

The integral autofocus function in today's compact, prosumer, and digital SLR cameras is a key parameter in the challenge of pet photography. The term refers to the camera's ability to correctly determine the point of focus when you half press the shutter release button. Unless you are going to be exclusively photographing tortoises, a fast focusing system is essential in pet photography, particularly with faster animals or when the camera is to be used in limited light environments. Some camera also suffer from "shutter lag," a delay between pressing the shutter and the shot actually being captured. Any lag will result in the intended shot being missed.

It is usual for digital SLR cameras to provide faster focusing mechanisms than compact cameras or those cameras often referred to as "prosumer" models (bulkier, pricier, and with more features than a compact camera, but not interchangeable lenses). Even cheaper digital SLR's invariably boast a feature referred to as "continuous servo-focus," which is especially useful for photographing pets as it allows the focus to continually adjust when tracking a moving subject, such as a dog running. Some more powerful compact and prosumer models may also have such a feature accessed via the main menu advanced controls, possibly called a "sports mode."

METERING

This term refers to the method by which the camera assesses the amount of light available and decides on how long the exposure should be. Some cameras possess both spot metering and center-weighted metering in addition to the standard "matrix" or "evaluative" metering offered on most cameras. In circumstances where there are brightly lit areas around the vicinity of a pet, the ability to use spot or center weighted metering may give you a more accurate picture of the subject, because the camera will only consider the subject, and not the brighter, outer areas, when determining the exposure. Cameras may also offer manual exposure compensation, allowing you to dial in or select a positive or negative exposure value to the camera's automatic choice.

ISO

This term refers to the sensitivity of the image sensor. The lower the number, the less sensitive the image sensor is to light. Most cameras offer an ISO range from anywhere between the range of ISO 80-3200. A camera providing a big range, perhaps with an ISO setting up to 1600 or even 6400 may be more versatile for pet photography than a camera with a limited range (say between 100 and 400). For example, you may be faced with undertaking an action shoot on a dull day. You may only achieve the desired fast shutter speed to freeze the motion of the dog by selecting a very high ISO setting on your camera if the aperture setting is already at its widest. This is due to the interrelationship between shutter speed, aperture, and ISO. Higher ISO settings do produce more visible noise in the images (the digital equivalent of film grain) and this varies from camera model to camera model.

Cameras & lenses (cont.)

APERTURE

The aperture determines the amount of light that can reach the camera sensor. In compact and prosumer model cameras a maximum aperture will be stated in the specifications. If you're using an SLR, the maximum aperture will be stated in the lens specifications, and may vary from lens to lens. The greater the maximum aperture, the faster your potential choice of shutter speed because more light can pass through a wider opening quicker than a smaller opening. In low light, or where a pet is moving, higher shutter speeds may prevent camera shake, which enables you to capture a reasonably sharp image free of motion blur. The focal length of the lens in compact and prosumer models usually has a direct linkage to the maximum usable aperture unlike some professional grade lenses. This means that the maximum aperture of $f2.8$ may only be available at the camera's widest zoom setting.

ZOOM MAGNIFICATION

In well illuminated environments, the optical zoom feature of a lens can be extremely useful for photographing pets at a distance. It will allow you to enlarge the pet in your viewfinder. Some may say that you could always move closer to the animal and this is indeed true but in pet photography many animals, especially dogs and cats, are rarely still. For example, you may move closer to a cat to improve the composition of an image only for the cat to move again. A zoom feature can therefore play an invaluable role in pet photography, making it less frustrating. There are also some safety advantages; if there is an element of risk you can be further removed from it. For example a Great Dane dog running at high speed towards you may not have the swiftest turn at the final moment and therefore the zoom may give you the opportunity to capture the shot and then roll out of the way before you are accidentally trampled on!

FILE FORMATS—JPEG OR RAW

A great debate often arises within photography circles on the best file format to choose. Most compact cameras will offer JPEG only, but more sophisticated cameras like SLRs will also offer Raw. A JPEG format image uses what is classified as a "lossy compression." In other words, some minor image detail is permanently lost from the image data during the saving process. At the opposite end of the scale, Raw image file formats store all of the information

the camera can record; not just the sensor detail, but the selected camera settings too. This offers far more flexibility than JPEG images can in post processing. The downside is that Raw image files are significantly larger, and require special software on a computer to view. That's because each camera model produces its own kind of Raw file, while JPEG is a standard.

Sounds confusing? Here's my take on the subject. If you are an advanced user of a camera and can accurately and consistently obtain the correct exposure and accurately select the desired white balance, then shooting in Raw will not give you a great advantage. If you are less experienced and have time to process images, Raw will be a great boon to your photography.

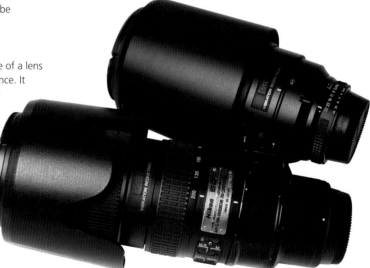

IMAGE RESOLUTION

There appears to have been a mad race over recent years to offer more and more pixels, with camera manufacturers using this parameter as a key selling point. Having more pixels certainly has its advantages, especially in post processing or where you wish to crop the image dimensions significantly, but it does not go hand in hand with quality. For instance, a camera and lens with greater optical qualities will produce far superior results than a camera with poor optics boasting double the number of mega pixels. However, higher pixel counts can be important where the image is desired to be printed at very large dimensions.

MACRO FEATURE

Many compact and prosumer camera models will boast a macro feature that enables you to focus extremely close to the subject, unlike a digital SLR camera where a specialist macro lens may be needed. With very small pets that are very tame due to frequent handling this can prove useful for taking detail shots of eyes and other minute features. In the case of animals that are easily startled, the silent electrical shutter of a compact may be a boon over the mechanical shutter found in an SLR. That said, electronic shutters usually have a beep sound notification signalling that the image has been taken. It's often beneficial to use any macro feature on a compact camera with the electrical shutter notification turned off.

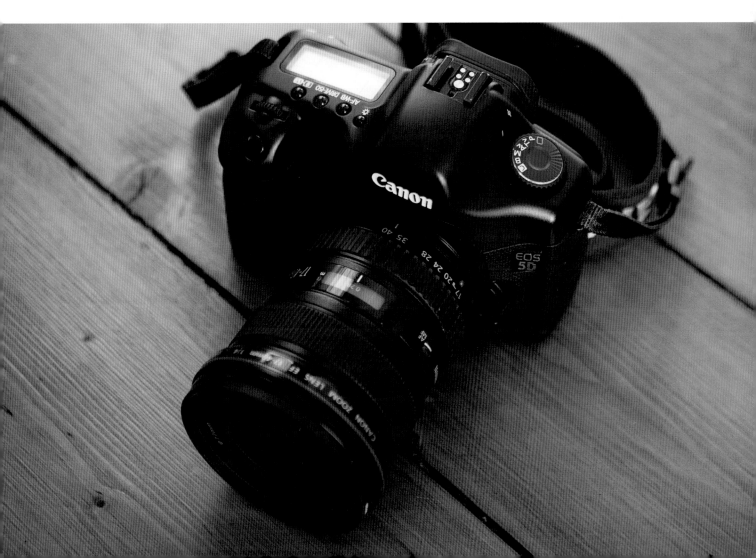

\mathcal{L}ens choice

DSLR owners have the benefit of being able to change lenses to suit the circumstances, and there is an abundance of different lenses on the market, from the cheap "jack of all trade" lenses typically included with entry-level SLRs to specialist lenses, like the "fish-eye." There will be lenses of the same brand as your camera, as well as third party manufacturers who have designed their lenses to fit other cameras (Sigma and Tokina are big names here). The advice that a colleague once gave me at the beginning of my own photographic journey was to "buy the best lenses you can afford." He wasn't wrong. It was sound advice and even today I'd always rather spend money on lenses than on new camera bodies that are launched year after year. There is no single lens in my kit bag that will be useful for all occasions given the variety of pets out there, it is good to have a range of options. The lenses that I most commonly use on assignments are detailed below, together with typical (but not exclusive) applications.

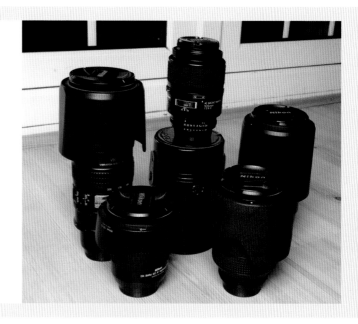

28-70 mm ƒ2.8 (opposite right)
Incredibly useful zoom lens for pets when the distance between the camera and subject is quite minimal, for example a cat sleeping in a basket, or when photographing groups of pets due to the wide angle view offered at the 28 mm end of the range.

70-200 mm ƒ2.8
Longer range zoom lens. Useful for pets where the distance between camera and subject is quite far, like a dog running.

50 mm ƒ1.4 (right)
Fixed focal length lens. Useful for photographing in low light, due to the wide maximum aperture.

105 mm ƒ2.8 macro (opposite left)
Fixed focal length macro lens. Useful for close-up shots, perhaps of facial features in caged animals such as rabbits or guinea-pigs.

1.7× Converter
This converter multiplies the focal length of the lens concerned. Hence a 70-200 mm lens effectively becomes a 119–340 mm lens (on a full frame camera) allowing a much more distant pet to fill the frame more.

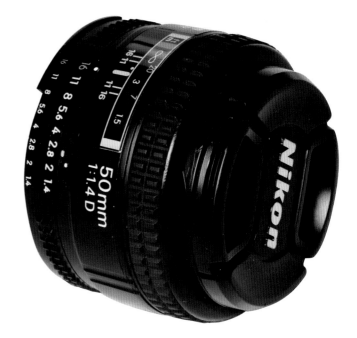

The majority of digital SLRs today are classed as non-full frame cameras. This is due to the sensors being smaller than the conventional 35 mm film. This results in what is termed a focal length multiplier. For example, the focal length multiplier on Nikon cameras (with the exception of the Nikon D3) is 1.5×, so a 70-200 mm lens mounted directly on the camera effectively becomes a 105-300 mm lens. Non full frame cameras can be especially useful for pet photography in that the majority of pets that I photograph tend to be further rather than nearer the camera and I am often at the 150-200 mm range of my 70-200 mm lens, helped by the focal length multiplier. A full frame digital SLR, has the advantage of being able to use higher ISO settings with far less noise visible in the image. Remember the dull day with the dark dog that is dashing along. The trade off is of course that you will need to be closer to the pet than with a non-full frame camera.

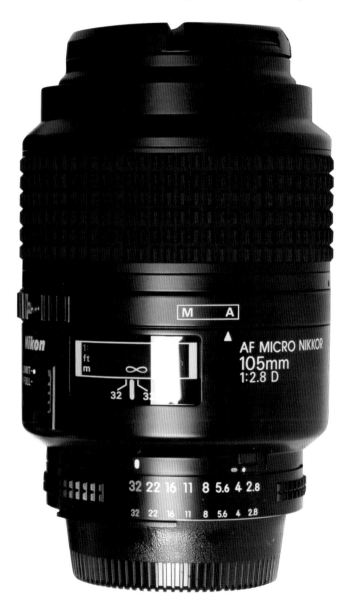

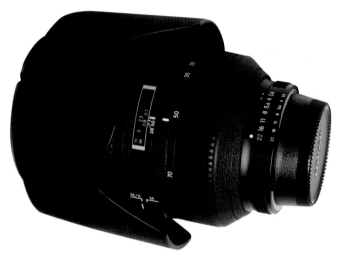

CONCLUSION

In respect of the vast array of camera and lens choices available within the market place today, your budget will inevitably be a deciding factor. Try and work out a fair balance between your bank balance and what extra little feature or advantage will be gained by the next increase in price bracket, and remember what you're buying it for. If you're shooting a lot of handheld work, a lens with a stabilizing system (at least for Canon or Nikon cameras) might offer more of a step up than simply looking for better glass. Advanced photographers will feel at ease deciphering the various parameters and the specifications assigned to them, but for beginners, I'd recommend reading reviews and specifications of lenses in your price range. Remember, it's not just the advances in camera technologies that can aid you in producing images that you'll be proud of. Ultimately, you make the key decisions, not the camera.

Computers & other hardware

Image enhancement and manipulation can be an extremely enjoyable part of the digital photography thanks to the availability of computers and photo-editing software. Your requirements for editing images, the amount of pictures you take on a regular basis, and your intended photo editing application will govern the computer and monitor system that you need. If you've not already got a computer, here are the key criteria to examine when shopping.

Get the largest amount of RAM (Random Access Memory) and hard disk space you can reasonably afford. In both cases higher numbers are better, with 1GB RAM a working minimum on Windows Vista and the latest Mac computers. If you intend to work with Raw image files then disk space, memory capacity, and extra processing power become even more important.

Another essential is a DVD (or Blu-Ray) writer. Backing up your image files to DVDs should be an integral part of your workflow routine, whether it is daily, weekly, or monthly, and a DVD writer is an extremely important device on any computer system. The more important the images are to you, the quicker they should be backed up. Other back up devices exist such as external hard drives, though after one such device failed on me and it cost a small fortune for specialist data recovery. Now I back up images to an external hard drive and a DVD.

These days I back up images to an external hard drive *and* a DVD.

Above: A laptop computer provides great portability for viewing images on location, although battery life and unwanted glare from light reflecting on the screen may present their own difficulties in turn. The latter can be eliminated by creating a black colored shade screen at the top and sides of the monitor, or by purchasing an off-the-shelf monitor hood.

Above: A typical external hard drive unit such as this unit provided by "Lacie" is a vital tool for storing your pet images. However, they should not be solely relied upon as the only mechanism for storing your images since they can fail. It is good practise to also back them up on write once removable media types such as CDs or DVDs.

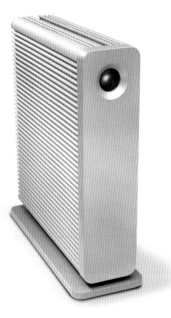

Above: Not as portable as the example above-left, a larger external hard disc is a sensible way of extending the life of an old computer system or backing up an entire catalog of images. It is not uncommon to find drives with capacities of around 1TB (1024GB). Put another way, that's 232 DVD-Rs.

Left: Blu-Ray might be the future of home entertainment, but it also offers a huge 25GB (single layer) or 50GB (dual layer) storage capacity for archiving photos. By comparison, DVDs hold 4.4GB or 8.5GB.

Above: This example of a portable USB "pen drive" is extremely lightweight and provides a good mechanism for sharing a series of images with a friend or relative by simply plugging the device into a USB drive on their computer.

Above: Cheap and affordable media such as CDs or DVDs still provide one of the most reliable forms of backing up your image data. It's also advisable to label your discs and keep an inventory listing with them to make finding the disc easier at a later date.

Below: This sleek modern, notebook computer from Apple provides another example of the superior portability that a laptop computer provides over a more conventional desktop computer. Even a machine as small as this can handle fully-fledged imaging software.

Lighting

Lighting is the key ingredient of photography and it is worth considering the various types of main lighting and choices available to a pet photographer.

NATURAL LIGHTING

The most favored lighting by many professionals, including myself, is that of outdoor, natural lighting; that which is provided by the sun. This natural light is great for environmental portraits of pets and requires no power, just dedication on the part of the photographer to seek out where the better quality natural light is in any given environment, something that we'll come back to later in the book.

FLASH PHOTOGRAPHY

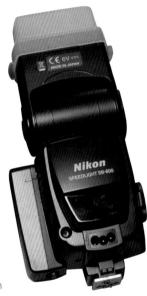

In addition to using natural light, the option exists to add artificial light; either the camera's own built in flash, an external flash, studio flash units, or some other form of continuous lighting source such as that provided from tungsten or halogen lights. Using any form of "flash" photography carries with it certain risks, not least that the pet might react badly to the light. The lighting provided by a standard camera-mounted flash can also be described as quite "hard," since it is being emitted from a small point source. This can look quite ugly and unnatural when used in pet portraiture, even with the flash's power reduced via any flash exposure compensation. Another potential problem, especially if the flash is mounted on the camera, or close to the camera, is that of "eye discoloration." This is the animal equivalent of red eye often associated with flash photography on people. It is caused by the light hitting and reflecting off the back of the retina. When photographing pets, the red eye effect is quite different. Animals have a reflective layer in the back of their eyes behind the retina called the tapetum. This layer enhances their night vision. The color of the tapetum gives you green, blue, yellow, or white eye effect depending on the animal.

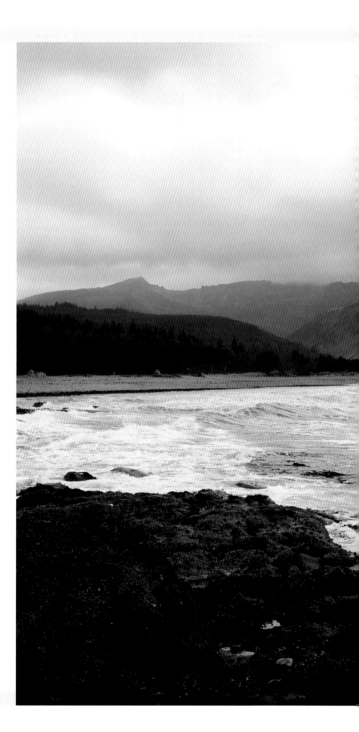

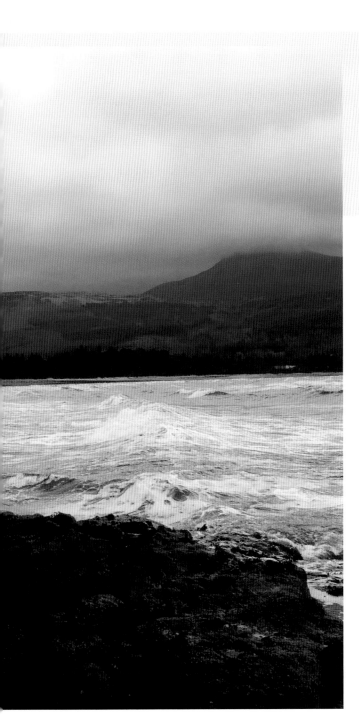

Left: A view of Brodick Bay located on the Isle of Arran, Scotland taken in the winter time. The dark, stormy sky adds real drama to the scene and the softer lighting characteristics provided by clouds filtering the sunlight make the conditions extremely favorable for any lighter colored dog. The placement of any dog in this scene and camera angle would be vital to ensure the dog was not lost into the background.

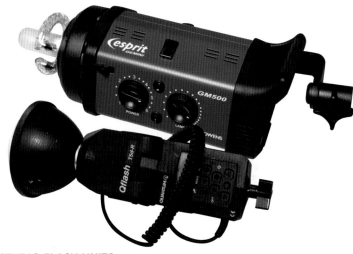

STUDIO FLASH UNITS

The use of studio flash units for pet photography can be very effective and this method of lighting is often used for commercial pet portraits. This avoids the need to rely on the unpredictability of the sun's appearance and natural lighting. It has the advantage of being consistent, and event photographers often favor this type of indoor lighting, using studio flash units on location combined with a background or portable "set" into which the pet is positioned. The disadvantage with this method of lighting is that the pet portraits at an event can look very similar to each other, since the background and lighting are consistent. It relies on the photographer to creatively photograph different stances and views, i.e. full length portraits, head and shoulder portraits, close-ups etc. Studio flash can also generate a great degree of heat that can prove uncomfortable or distressing for the pet. Therefore this method should only be used for a limited time with any pet.

Bag of tricks

Pets, being what they are, undoubtedly need a little persuasion from time to time to focus their attention in the direction required. The most obvious attraction for most pets is that of food or treats. Some pets are "ruled by their stomachs" as the saying goes, and will do almost anything for a treat; though you still need to be able to show your subject how they can earn their reward. In respect to dog photography, food treats can be either a help or a hindrance depending on the obedience level of the dog. For instance, balancing a dog treat on the lens hood may result in fixated eyes of a well trained dog looking directly at the camera. Whether others, however, it could simply mean that your camera lens will need a thorough cleaning to remove the dog's saliva! In either case, talk to the owners to see whether they think treats will help, and see if the pet is on a special diet. We used to own a cat that would ignore all human spoken language, barring the word "prawn." Guinea pigs may also respond favorably to lettuce leaves.

Some pets will have a close association with their handlers and their own characteristic sounds that they have become accustomed to from being a young age. Many dog handlers for instance have their own whistles or calls that the dog will respond to (most of the time). My own dog Millie responds to a two tone whistle, except in the presence of squirrels when her hearing is apparently switched off! It really is worth experimenting with a range of different sounds that you can make with your own vocal chords and seeing the response that you get. It's obviously worth doing this behind close doors first rather than in any public arena; be prepared to get some funny looks otherwise. Aside from your own talents at producing noises ranging from whistles to raspberries, you can also find a vast range of different noises that can work to great effect. For example empty chip packets, squeakers contained within soft toys, duck noises, and shepherd's whistles are just some great attention grabbers.

Some animals love to be stroked, particularly cats and dogs

The use of visual stimulus in cajoling pets to look at the camera is a key weapon in your armory of tools. For instance, does the pet have a favorite toy? Does the pet respond better to one family member's presence than another's? Does the pet respond to hand signals, as in the example of a well trained dog? Does the pet suffer anxiety if its handler is out of sight? Does the pet recognize the sight of its own food treat container? These are just a few questions from many that you may need to consider or discover. One of the best examples of a dog/handler interaction using its sight sense (combined with hearing) is that observed during a dog agility event, with the dog continually responding to the body language and hand signals of its handler.

Finally, don't forget the sense of touch. Some animals love to be patted and stroked, particularly cats and dogs. Horses can also be reassured by their handler by patting and stroking. In some cases, these actions can be extremely useful for the photographer prior to the assignment taking place since it can reassure a pet that everything is okay and keep an animal calm. This can be most useful in enclosed environments.

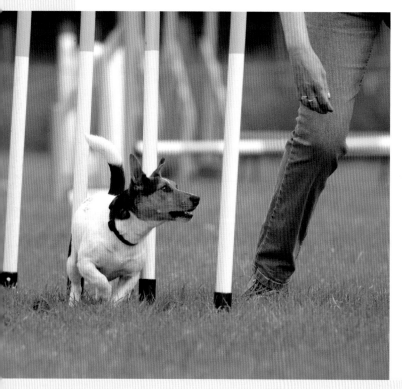

Left: This Jack Russell terrier dog is fixated on its handler and is continually looking for signals and commands for its next movement, even while weaving through the posts.

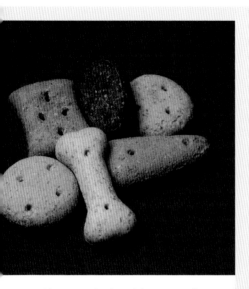

Above: A selection of dog treats. Always have them on hand, but keep them hidden from sight (and nasal senses) until needed.

Above: If edible treats aren't getting you anywhere, then don't underestimate the possibilities offered by toys, especially those with squeakers.

Right: This old cat loves the attention of its owners and welcomes the ear scratch prior to the photography commencing.

Sets & props

The decision to use props in pet photography comes down to personal choice. The question that needs answering is what is to be gained or lost by the use of any chosen prop in a scene or "set." They need to be selected carefully and complement any existing objects. Many event photographers that create studio sets will carefully choose a range of props to match a particular theme or setting that they are attempting to recreate. For instance, if the scene set was that of an old barnyard, then straw bales, old milk churns, and a pair of old boots may fit the scene well. Similarly, if the scene was a modern living room then perhaps a mini sofa, table lamp, and rug may be appropriate. The key to successful sets and use of props for event photography is ensuring that the allocated space for the dog or groups of dogs is adequate to cater for the likely mixes and sizes of pet. The colors, tones, and placement of any props within the set should usually be chosen so as not compete with the subject for the viewers attention. For example in a farm set, a pair of black or green boots would look far better than fluorescent pink ones! There are all kinds of available products on the marketplace designed to enhance a set, ranging from spray on cobwebs through to polystyrene rocks and boulders. All it needs is some imagination and creative flair.

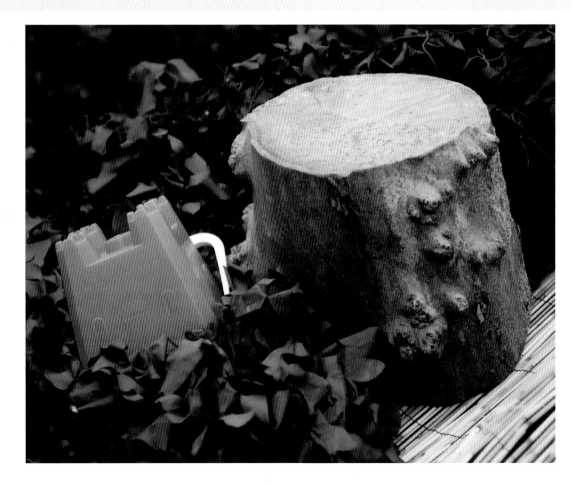

Left: Your choice of props should be made with care. For example, the fluorescent bucket observed in this image is likely to be more "eye catching" than any pet due to the vibrant color that it exhibits.

Opposite: The camouflage netting prop in this basic portrait image provides a simple yet complimentary setting for the West Highland White terrier dog.

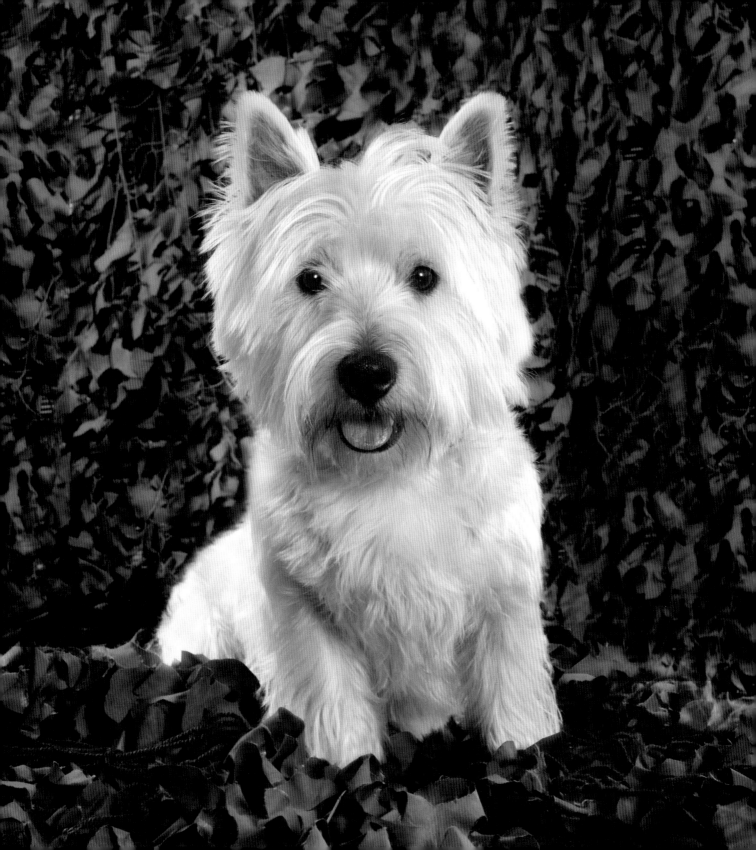

Preparatory homework

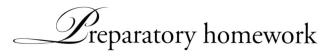

The more advance knowledge you can have of a particular pet and its habits prior to meeting the animal, the better. This can only be gained doing some research beforehand. For instance, if you know what the particular breed is in advance (one dog is very different from another) you can read up on some key characteristics and start to anticipate the physical appearance of that animal: its coloration, distinguishing markings, and expected size. It goes without saying that anything read in a horse, cat, or dog breed profile book should be regarded as a rule of thumb since there can be many varieties within a particular breed, not to mention sub-breeds and mongrels. However, it will prove a useful yardstick. The handler will also be able to confirm any other physical characteristics that may not conform exactly to the breed standard. Prior to meeting any particular pet you can also ask about other characteristics such as age and ailments. If the pet suffers from any ailments of old age or have any other disabilities, such as only having three legs, you will want to have strategies to deal with this in advance. It is also worth ascertaining as much as possible about the temperament of a pet in advance. For example does a particular cat dislike strangers? If so it is more than likely to disappear on the photographer's arrival. How does the dog respond to other dogs or young children? Is the pet a rescue cat or dog, and thereby possibly inclined to react to certain trigger commands, whatever they may be?

Research material: As long as I've been photographing animals I've been adding to my book collection. Dedicated authors have uncovered a great depth of knowledge about virtually every kind of pet, and their work is always my first starting point.

> Seek out knowledge beyond just the physical characteristics; find out about temperament and behavioral characteristics.

Aside from the anomalies, a great deal of information about particular pets and breeds of pet can be gained from many reference books and the Internet. For example, my own book shelves contain encyclopedias on dogs, cats, horses, and even rabbits and rodents. It is also worth spending time with handlers of different pets on any photographic shoot and learning as much as possible about pet psychology. The classic example is the tail wag of a dog which when wagging from side to side usually indicates that the dog is in a happy state of mind. The wagging tail of a cat usually indicates that the cat is not particularly happy. Therefore do not assume that the same animal behavior characteristic translates the same way in different animals. The author Desmond Morris has written some excellent books on animal behavior and has titles referencing *Horsewatching*, *Catwatching*, and *Dogwatching* that provide a great understanding to everyday observed characteristics. From any conversation with the pet handler or owner you may also gain an insight into the general obedience level of the pet concerned, and this may steer the props or triggers that you may wish to take on location with you.

The owner informed me that "Bud" liked climbing trees and this shot typifies this behavior. The owner also told me that "Bud" would frequently walk through the culvert, so it was important to capture such an image since it was one of the dog's traits.

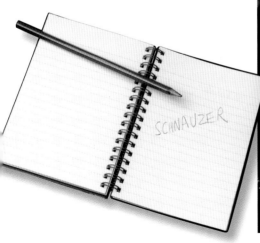

SCHNAUZER

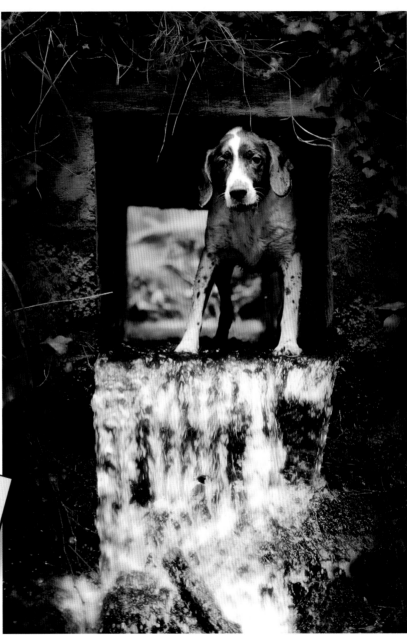

SO WHY IS SUCH INFORMATION INVALUABLE?

The information obtained from the advance planning can aid you in a number of ways, not least because it will help create a safe and yet enjoyable pet photography session. All being well it should also go a long way to helping you get some great results. For example, perhaps your task is to photograph a Standard Schnauzer whose color markings can either be black or a gray. The latter is often termed "salt and pepper." Other physical characteristics of this dog in a typical breed are a beard and distinctive eye brows and darkened patches around the area of the eye sockets. In terms of natural environmental backgrounds this breed can be very easily lost into the background of any scene. In this case lighter or colored backgrounds tend to be more effective unless the dog is positioned in a band of distinctive light entering a particular location enabling the dog to be "highlighted" and easily distinguished from the background scene. The dark eye sockets and eye brows are also potentially a problem for mitigating the effect of any nice catch light being displayed in the eyes of the dog. Some breeds have very distinctive and prominent eyes such as a Pug so it is much easier for the catch lights to be seen in their eyes providing the light source is not too high and is directed into the face, rather than the back of the head.

Many of the guide books on rabbits, cats, dogs, and horses may provide you with excellent physical descriptions during the life-cycle of the animal yet be more limited at describing the behavioral characteristics of a particular breed. It's therefore worth seeking out a book that goes beyond just the physical characteristics and highlights temperament and behavior.

All of the information gleaned adds further pieces to the jigsaw puzzle that leads to the decision making about possible

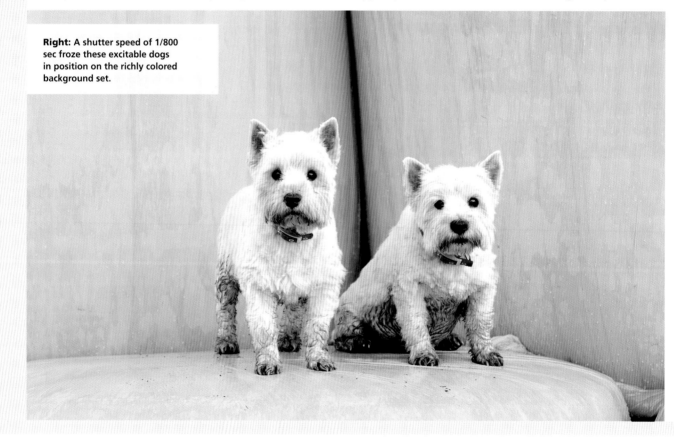

Right: A shutter speed of 1/800 sec froze these excitable dogs in position on the richly colored background set.

environments in which to photograph the pet. In circumstances of house pets such as guinea pigs, rabbits, or breeds of cat, your environmental choice may be made for you already. In such circumstances you will need to think creatively upon arrival and make the best of what you have. The temperament of the pet, its energy levels and behavior can also steer the choice of environment. For example, a disobedient dog that is easily distracted and has behavioral problems is better being photographed in a safer environment such as an enclosed park or field than an open, scenic environment. This ensures the photographer is safe in the knowledge that the session that will be both enjoyable and without risk. The scenic location may offer what I (and Forest Gump) would call a "chocolate box" of different options but, on the downside, it may also be frequented by dozens of families and other dogs that will cause a distraction to the session.

Above right: Knowing that the dog's eyes would follow the movement of the stick in the handler's hand, he was asked to stand off-camera to the left of shot.

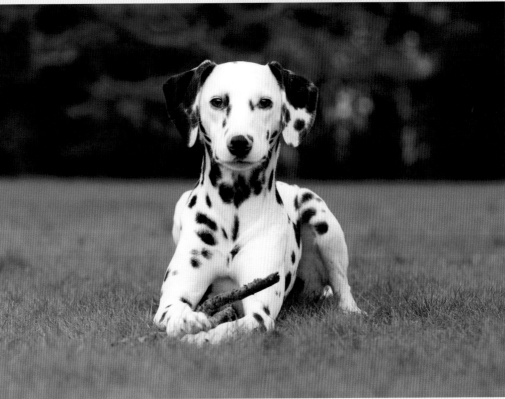

Right: This dalmatian is happier when visitors get down to his level, but by the looks of things he's still not planning on giving up the stick.

\mathscr{T}iming the photography

When is the optimum time of day to photograph pets? You may wake up one morning, open the curtains, and witness the most amazing sunrise and "golden light" enveloping the hills on the distant horizon. So you excitedly check your schedule for the next day and plan to be there with your dog at the same time. The next day you might arrive on location, wait patiently for the designated time but unfortunately find yourself without the magical light you were anticipating. It can be very frustrating.

Even indoors the same scenario may occur if the room takes much of its light from windows. A beautiful sunlight may fill a room for a few hours in the afternoon, and this natural illumination will be far more pleasing to the eye than on other days depending on the level of cloud cover, dust in the atmosphere, and a whole host of other light filtering characteristics.

There are two natural elements that are certain and predictable when it comes to choosing the most favorable time of day for your outdoor pet photography.

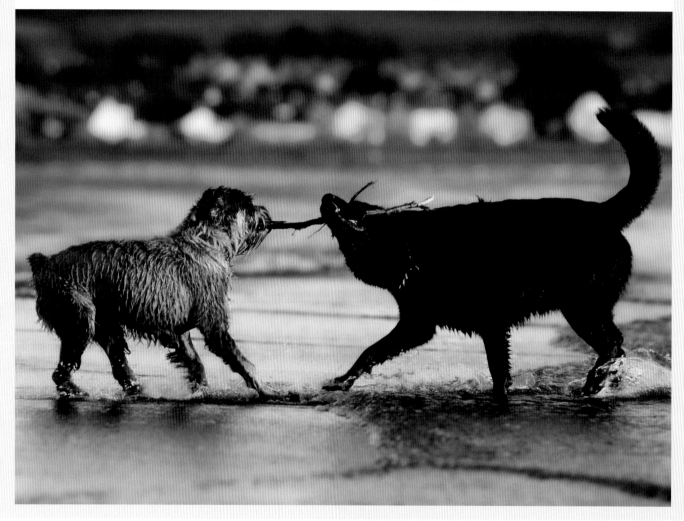

ANGLE OF THE SUN (LIGHTING DIRECTION)

The sun's angle at specific times of the day varies throughout the seasons. Photographing when the sun is at a lower angle such as just after sunrise or closer to sunset is potentially going to give you more dramatic images than the mid-afternoon sun of the summer when the sun is at its highest in the sky. Utilizing a low sun will give stronger reflections in water and other surfaces and will increase opportunities for silhouette images and rim-lighting. Some dogs with deep, dark eye sockets such as the Schnauzer can also benefit from the lower lighting which provides illumination into the eye area. The light at this time is also considered warmer because the sun's rays pass through more of the atmosphere (traveling at an angle), and this has a filtering effect on the blue segment of the color spectrum. The resulting warmer yellow and orange tones of light can be much more pleasing to the human eye than the high midday sun which is associated with colder tones.

The reality of pet photography and other fields of photography undoubtedly come back to the basics of lighting. The illumination presented may not be the most desirable but it will have strength, direction, and contrast quality that can be exploited or manipulated by a good photographer.

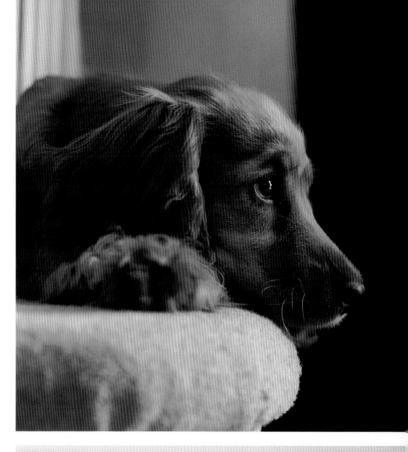

Utilizing a low sun will give stronger reflections in water

TIDE

Low tide-times are known, and easily obtained should you be fortunate enough to have access to a stretch of coastline. Typically dogs and horses love a beach to sprint across or explore and a beach at low tide presents a greater abundance of creative photograph opportunities than one at high tide.

If the tide-times allow, combine an early morning or sunset shoot with a low tide and the potential ingredients for a great photograph become ever tastier! We'll carry on exploring ways to use different environments to your best advantage further within the rest of the book.

Opposite: My dogs Millie and Sam attempting to win the battle of the stick in the golden light of an evening sunset.

Top: This spaniel was naturally illuminated by a high window in a front door panel. The angle of lighting is visible in the catchlight present in the near eye of the dog.

Bottom: The back lighting in the last hours of daylight exemplifies the "silhouette" image of the Schnauzer in the water.

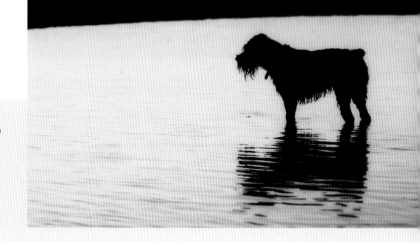

\mathscr{P}et owner

Although I've already talked at length about the pet's characteristics, there's another part of the equation: the client. Of course you might well be the client, but if not you'll need to ascertain whether the pet owner has any specific picture requirements.

My own preferred style is to capture pet portraits that display their wonderful characteristics

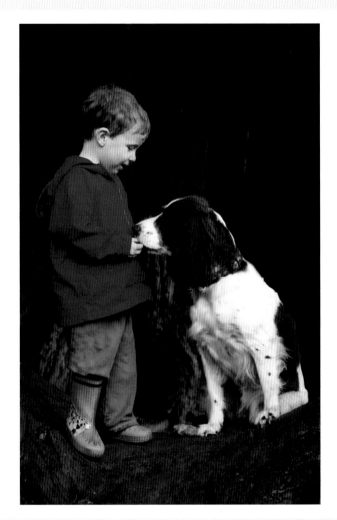

Many will not have any idea at all and will leave it up to you, the photographer, to conjure up some magical images. Other owners may have previous portraits of pets and will be looking for an image that can be matched to their existing collection on their wall. It may be that an owner of a pedigree pet has requested a full length profile image of their pet to show excellent breed conformation that they can proudly show to friends and family. They may be thinking of a studio type portrait. It is certainly worth asking the question. My own preferred style is to capture pet portraits that display the character of the pet concerned. This is easier to discern in dogs, cats, and horses, rather than say a rabbit or a tortoise, but it is something to look for either way. If you have ever seen a dog in a car becoming excited as he realizes he is en route to a particular location and upon exiting the car you can almost sense that the dog is smiling? Its behavior upon being released from the car may be to dash about 600 ft (200 m) as the excitement unfolds, followed by a release of its bowels (dogs are used to "walks" having this unmentioned aim, after all). With that out of the way, the same dog may just love running with other friendly dogs that it meets during its daily routine. You can capture images of a dog's typical and much loved behavior that evoke the sentimentality in owners for years to come.

This page: This old tree in one of the nearby parks provided a great opportunity to photograph my son with a friend's spaniel. Boys like to climb trees and the dog never says no to treats—the perfect combination. This shot was captured at 66 mm, f2.8, ISO 400, 1/250 sec shutter speed.

Opposite: Another combination of "children and animals." This Jack Russell cross terrier was extremely loyal to this young girl. The black face markings of the dog, compared to the paler complexion of the young girl, steered me to take this image using frontal lighting. The tone of the image was achieved later using Photoshop. The shallow depth of field was achieved with an aperture of f2.8 yet it was critical to keep the dog and girls face on the same plane.

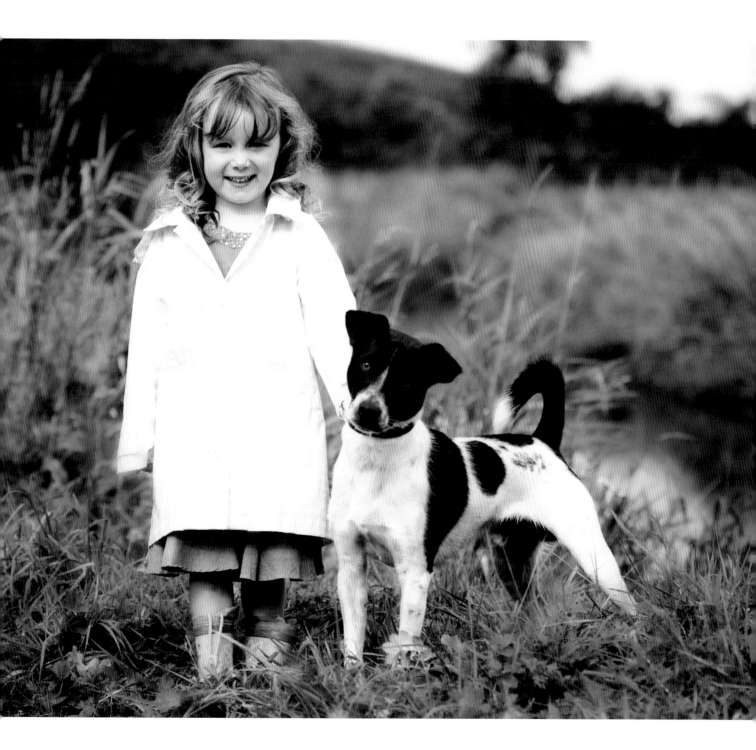

PET OWNER

Pet grooming

The pet or pets to be photographed should ideally be groomed or at least well presented in a manner that will be pleasing to its owner. This does not necessarily mean a shampoo and wet trim for every dog or brushing a cat to show standard, but it does mean paying close attention to certain areas that can hamper a good portrait or at least save you editing time in post processing. They key area is the face and the eyes and the vicinity around the eyes of a particular pet, so you must ensure that they are clean and are free from debris. Can the eyes actually be seen? Eyes add expression and character to any pet portrait, especially head and shoulder portraits and should be visible. Another area could be clumps of matted coat that look irregular in appearance when compared to the rest of the coat. It is worth asking the handler to examine the pet prior to you arriving and make sure that they are happy with its appearance.

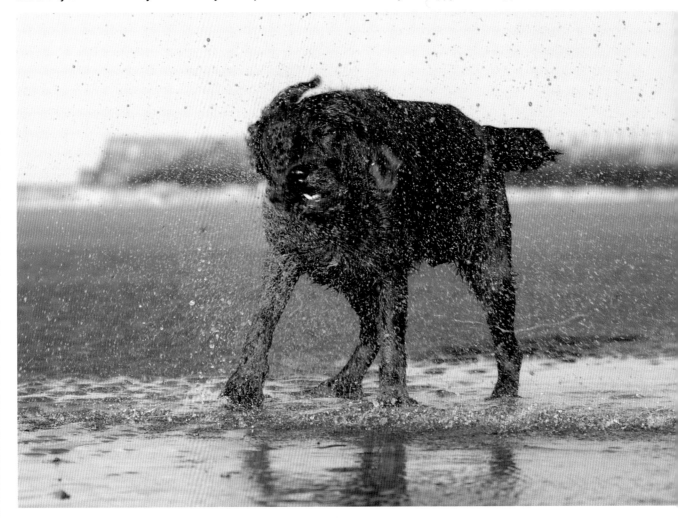

Dog groomers are certainly easier to find than cat groomers and it can be quite a challenge on the part of the cat groomer to conduct their work when a cat is clearly not entirely happy about having their appearance improved. Some cats may love the brushing stage while others are merely tolerant, putting up with the routine and having become accustomed to the practise since a young age. Other cats may also have to be sedated for the grooming to take place. They key decision on the part of the photographer in collusion with the owner is to assess how quickly the photography should take place after the grooming exercise. For instance the last thing the cat would need after being quite stressed out by the groomers is a photographer to be pursuing it. Dogs tend to be more resilient to grooming and changes of environment and should be ready for the photographer much quicker than their feline friends, yet it's always worth checking with the owner and asking how the animal was at the grooming parlor.

Left: Be aware of the timing when you introduce some dogs into a water environment, since the well groomed pet look may not last very long with certain breed types.

Above: This dog was kept indoors after grooming.

Right: The last thing a photographer would want would be a stressed cat that had just returned from the pet groomers.

Safety & welfare

The health, safety, and welfare of both pets and the photographer also need to be considered as an integral part of any photographic shoot. This is particularly important in the planning stages when opting to photograph in the vast possibilities of the great outdoors. It would be a great shame if any superb images in the camera were spoiled due to an avoidable incident of one kind or another.

You should understand all the hazards to yourself, the pet, and handler

For the photographer and pet handler, it is important to ensure that they have the appropriate footwear and clothing for the environment selected. That might include hardwearing boots, a change of clothing, and waterproofs if necessary. The photographer may also want to consider investing in a pair of chest waders if entering a water environment. You will also need to be aware of the hazards that any environment is likely to present to both the photographer, pet, and handler. Likely candidates are water safety, nearby roads, fields of grazing animals, potential broken glass, dog excrement (from irresponsible dog owners that haven't picked up), and the need for land permissions. If photographing on a beach or dusty environment due regard must also be made for the tools of the trade: in other words make sure your camera is protected from the elements.

The information obtained from the pet handler earlier should also be used to ascertain the risks of any selected environment for the pet concerned. For example, a pet's obedience level and behavior patterns will best dictate where the shoot will take place. It's important to consider its behavior around children, other dogs or other animals, or when it is taken off the lead. This may apply to some breeds of dog more than others; particularly those that are scent oriented, or herding canines such as collies. The integrity of any leads and collars should also be checked, especially if crossing a potential hazard area en route to the chosen location.

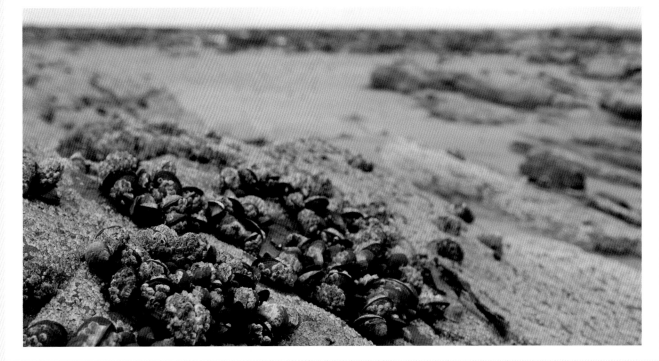

The measures and planning undertaken should be proportionate to the risks. It is impossible to envisage all risks but with proper planning and consideration they can be minimized and the photography can be an enjoyable experience for the pet, its handler and, of course, the photographer.

SOME ITEMS TO CONSIDER WHEN PHOTOGRAPHING OUTDOORS:

Pet behavior characteristics
Pet fitness/health
Suitable footwear for the terrain
Suitable clothing/waterproofs
Towel
Change of clothing
A First-Aid kit
Anti-bacterial wipes
Scoop bags
Leash/collar/harness integrity
Cellphone

SUMMARY

It is impossible to decipher all of the pieces of the jigsaw puzzle before arriving on location, but it is beneficial to be as prepared as possible in terms of any photographic equipment needed. It's always best to ensure that you have a reasonable amount of knowledge about the pet you are about to photograph.

Opposite: These clinging barnacles adhering to the rocks on this beach area may be fine for most dogs, but older dogs or those with less than the toughest of paws may easily receive a small cut unknowingly from the pressure and angle that a paw is applied to such a surface.

Top: A pair of good chest waders is a useful piece of clothing for beach or water environments. I have been caught out too often in the past by a big wave, or by crouching down too far in the water, so I always have these with me in the back of the car on any assignment.

Bottom: Other useful pieces of non-camera equipment worth having available to you on any pet photo shoot (and indeed many other shoots). The first aid kit and anti-bacterial wipes are extremely important.

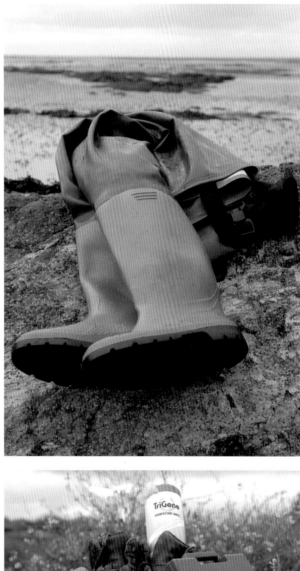

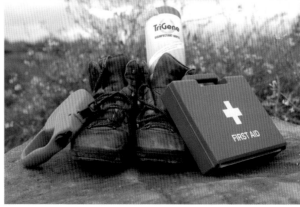

Having prepared and collected your equipment, charged your camera batteries, and conducted your preparation work, it is time to meet the awaiting animal. Despite all your preparations—and regardless of whether you have several years of experience or this is your first shoot—you will frequently be surprised or even amazed at the antics and unpredictably of characters within the pet world. In my case some of their names are still burned into my memory: "Edna," "Alfie," and "Daisy Dumps" to name just a few. These pets were all unique in temperament, and unable to fit the mould; and certainly accelerated my learning curve! In other words, never assume anything and be prepared for surprises on each and every assignment.

Shooting

Upon arrival at the pet's location, it is sensible to keep your camera equipment locked and out of sight in the car. It's important to meet the pet first without the camera bag. My particular camera bag happens to be red in color and I'd hate to be mistaken for the postman by some hungry dog! Once on the premises, if the animal hasn't already greeted me, I'll ask the handler to tell me more about their pet's traits. For example, it may be that the animal doesn't like certain sounds, being patted, or has other dislikes. You'll probably find that, in an environment they're comfortable with, the owner may remember a lot of details about the pet.

I wouldn't advise giving direct eye contact to the animal at first

In the main, with dogs and cats, my strategy is often to move around slowly, speak fairly quietly, and perhaps pet the animal when and if I think it's appropriate. I wouldn't advise giving direct eye contact to the animal at first, but to wait until you think it's accepted you as a friend of the family. I would certainly never stare into the eyes of a pet. It can be a good idea to greet a pet low down to the ground, especially with rescue animals. This lessens the threat of a dominant figure and is a particular technique I've used with animals that have been perhaps maltreated in the past and are naturally wary of strangers. By assuming a more submissive position to the animal you may increase your chances of becoming best friends as the session continues. Another key part of this stage is to closely observe the relationship and interaction that the pet has with its handler. For example, how close does the pet stay to its handler during their movements around the house? How responsive is the pet to its handler's commands? Does the pet suffer from selective deafness, with its hearing improving dramatically when food treats are around? How playful is the pet? How obedient is the pet? Your knowledge of the different breeds of dog or cat will give you a head start in the decision making process but never assume anything. The objective of the introductions is to decipher what kind of shots may or may not be possible with the pets concerned (and to do this as quickly as possible). Also, if the handler has requested a group portrait of his or her three dogs, you should find out as much as you can about their dog-to-dog interactions. It's likely the owner will know which of the dogs is the pack leader, which is the hardest dog to photograph, and for what reason.

Even if you are photographing guinea pigs, the same kind of observations may be needed. Is one guinea pig tamer than another? Do the guinea pigs stay where they are placed or move after a few seconds? Realistically, the more pets that are put into the intended photograph the greater the odds of problems occurring, so keep some spare memory cards, and of course you'll need to have the self belief that some magic will be created.

Left: In the interest of your own safety it is certainly worth ascertaining which entrance is to be used upon arrival, and exactly how much you need to beware.

Opposite: This image showing the three Yorkshire terriers at the doorway was achieved with a distraction in front of the terriers, and a handler out of sight of the main door. The dogs couldn't be relied upon not to make a dash, so their leashes (leads) were left on but cloned out later in Photoshop. This is certainly a new possibility in the digital age, though ideally not a first resort as it does take extra time.

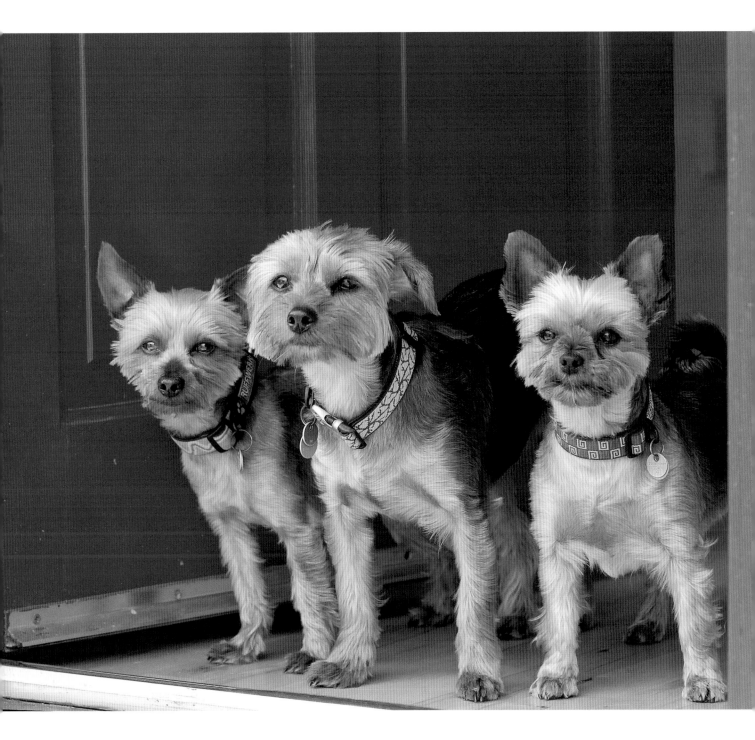

ON ARRIVAL

Choice of environment

Following the formal introductions and presuming that you have been accepted by the pet (or at least tolerated), it is necessary to build the game plan that will be enacted once the camera is retrieved. The level of domestication is important: house cats, or caged animals will likely need to be shot within the home. Horses may have their own field or stables, or can be transported to more open terrains perhaps with the intention to get a rider/horse image.

Homes can be chocolate boxes of opportunity or an equally difficult environment

Dogs typically have far greater flexibility than any other pet in that they are able to be transported without a great deal of trouble and can be photographed in perhaps the greatest range of environments. It's imperative that the handler is consulted on such matters and is agreeable to the chosen destination. Nothing should be taken for granted—the pet may have a heart condition, be intolerant of other pets or people, or have some other affliction that may eliminate location choices from the list. This is a problem you should have headed off at the planning stage, however. Cats are more than likely to be photographed in and around their own home environment, as are smaller animals such as rodents. Assuming a wide choice, here is a short list of just some of the outdoor environments you may want to consider for a photography session, and some of the issues they might throw up.

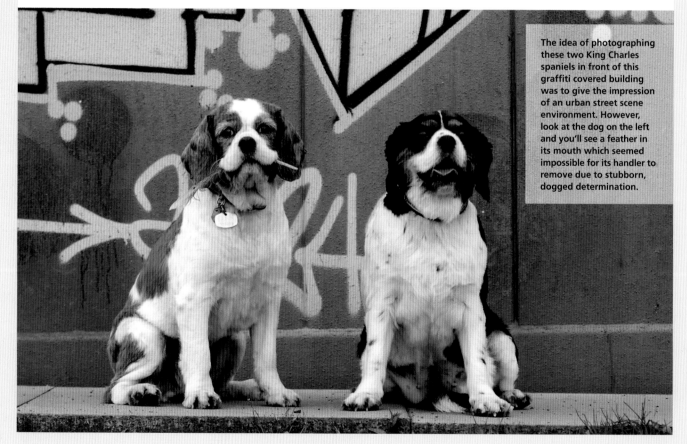

The idea of photographing these two King Charles spaniels in front of this graffiti covered building was to give the impression of an urban street scene environment. However, look at the dog on the left and you'll see a feather in its mouth which seemed impossible for its handler to remove due to stubborn, dogged determination.

WOODLAND

Lighting may be limited depending on the density of the tree covering. Lighter colored dogs may be favorably photographed in denser woodland, but restricted light will probably limit you to portrait images of more obedient pets. Action shots are problematic since higher shutter speeds are needed.

OPEN COUNTRYSIDE

Lighting levels may be in abundance, offering greater photographic possibilities, from still portraits to high speed action. Be aware of land permissions, country roads, and surrounding livestock, not to mention exposing for the sky rather than the subject by mistake.

SANDY BEACH

A potentially fantastic environment for dog and horse photography, thanks to the presence of water, uncluttered backgrounds, and the variety of sand textures (from dry and light, to rippled with reflective pools). Remote beaches are preferable since they will have fewer distracting people and animals around.

URBAN ENVIRONMENT

Dogs may need to be on a leash, but great possibilities in terms of varied backgrounds of different textures and patterns from brickwork and other manmade structures. You can also find a great variety of color tones in the built environment, especially in a commercial district. Any dog will need to be accustomed to potentially crowded places, and have conducted its "business" before entering such an area. Cats might be happier in the residential area they are already used to loitering in.

PARKLAND

A popular environment for many dog handlers but there may be significant distractions from other dogs being walked off the leash. Quieter, less formal areas of the park may have the most potential to provide interesting textures and backgrounds to an image, especially when deliberately thrown out of focus.

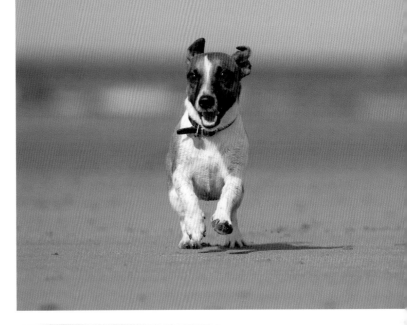

Top: The space and uncluttered environment shown in this sandy beach environment is often perfect for action dog photography. You can almost sense the joy in this Jack Russell terrier's expression as it runs towards the camera.

Bottom: The background environment for this head-and-shoulders portrait of a German Shepherd compliments the coloration of the dog's coat. The tonality and contrast difference is just sufficient to make the dog stand out, but the eye is drawn to the darker areas, like the dog's eyes.

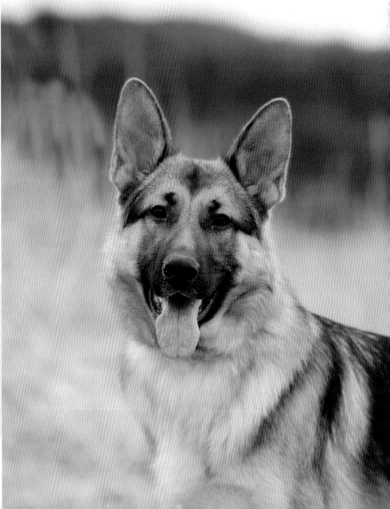

Choice of environment (cont.)

HOUSE

A multitude of different options, depending on the lighting arrangements, furnishings, and upholstery. Consider whether space or lighting is limited for the particular photographs that you hope to achieve. Light, well kept homes can be chocolate boxes of opportunity, but you are just as likely to find challenges. Good equipment that excels in lower light levels is essential.

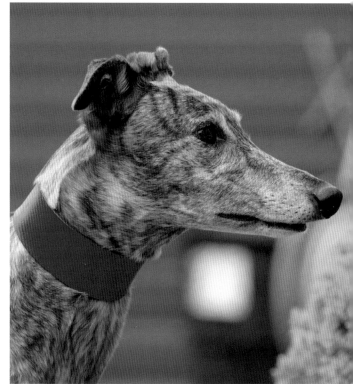

YARD

Is the yard colorful and well maintained with neatly cut lawns? Or does it possess a wild, unkempt appearance with longer grass and old weathered stonework. Actually it matters relatively little, so long as the pet is familiar with and relaxed in its own territory. In many cases the less fastidiously maintained areas are the ones in which the pet feels most at home.

Once the environment has been established, the next port of call should be to ascertain the possible or preferred locations within it. This means examining the light, backgrounds, patterns, working space, distractive elements, and the pet subject.

Selecting a spot doesn't mean the pet will agree, of course. It might be that a warm radiator inside the house is much more to the animal's liking, for example. The pet handler may well turn out to be one of the most useful assistants you can have. At the same time there are various rules that the handler needs to understand if he or she is to assist with the orchestration of the pet shoot. These will be documented later. However, let us first consider the indoor environment, which is so often far trickier than the great outdoors as far as light levels are concerned.

Far Left: This kitten was extremely wary of strangers to the house and would have disappeared at the first sign of any flash illumination. A fast ƒ1.8 lens was certainly useful given the lighting levels present. The fireplace behind the kitten also aided the composition in this image. A 75mm focal length was used at 1/250 sec.

Left: It took almost 45 minutes before this rescued greyhound dog was comfortable with my presence, especially holding the camera. The image is enticingly colorful thanks to the painted wall behind, but the depth of field effect keeps your eyes on the subject.

Right: This light falling on this piece of open woodland, and the pathway for dog walkers, will change dramatically during the day as the sun's position (not to mention that of any cloud cover) changes.

INDOOR LIGHTING

Explore the available rooms, examining the intensity of light both from natural sources and artificial light sources. Note its brightness, quality, and direction. Experiment with all the artificial light sources available to you, and take some test shots to see how the camera's White Balance feature handles them. Similarly, check to see if the natural light within any rooms can be enhanced by adjusting curtains or opening doors. It may seem obvious, but in the heat of a pet shoot, its surprising what you can forget, especially if you are busy concentrating on the pet.

FURNISHINGS & OBJECTS

As you explore rooms, visualize the chosen pet in each available room or area. Will the colorings and markings of the pet allow the pet to be prominent in the scene or will it be camouflaged by similar patterns or tones? How much does the view change as you move around the room, and can you eliminate distracting elements or colors by changing your angle? Is there any scope for moving or removing furniture, or using the furniture or objects presented to hide the distracting elements? If you're in someone else's home you'll obviously need to ask permission before it is turned on its head. Be careful too of antiques, ornaments, or anything delicate. Finally, do you have sufficient space to accommodate the pet, yourself, and possibly the handler from your chosen angle?

DANGERS

If the pet is not accustomed to a particular room, it may either not feel relaxed or be curious to explore its new surroundings. Ensure that if a room is to be used that all potential hazard are removed or minimized. For example, are there any holes in the wooden floors where the hamster can disappear? Is there rat poison in the corners of a window lit basement? The owner of such a property will readily give you the necessary information.

OUTDOORS

The considerations for the great outdoors are not dissimilar to those indoors. The lighting must be considered and the colors, tones, patterns, potential angles, and backgrounds should all be accounted for. Likewise, the potential hazards must also be assessed.

SUMMARY

The reconnaissance should enable the photographer to understand each location's strengths and limitations prior to the pet entering that particular environment. If you find that you are photographing an evasive and self-ruling house cat that walks from room to room and perhaps gives you a minute of its time in each room, you should at least be armed with the knowledge that you understand where the best possible angles are in advance, and what the likely exposures and background/composition arrangements will be.

The pet

The last thing that you need to assess is the pet's character and obedience level. Does the pet take no notice of you or the handler, pay limited attention when it suits them, or it is very responsive at all times? Obviously some pets can be expected to take no notice, unless perhaps in the presence of food. It isn't unusual, however, to find that a tamed house rabbit may be far more responsive than a lively Yorkshire Terrier.

The owner should certainly be able to provide you with enough clues to give you a good understanding of the pet and the challenges that may lie ahead. I have encountered an abundance of different temperaments and obedience levels over the years and it is precisely this challenge that makes pet photography both appealing and interesting. The behavior of pets continually surprises you no matter how much you think you know about a particular animal or breed. The following examples serve to illustrate my point though some real life situations.

PUBLIC PARK

Isla, the cross Spaniel-Labrador from London was an extremely happy, well loved dog with a generally high level of obedience (except, perhaps, when eyeing a squirrel). She had an extraordinary long tongue and a tail that wagged permanently. Her coat was in great condition and she had the advantage of being prepared in advance of the shoot. Her good behavior and disinterest in other dogs allowed her to be photographed off the lead for the most part. Both Labradors and Spaniels typically have a love of water, and as one of the pictures captures clearly, it wasn't long before Isla found the only water in the park. This series of shots documents the variety that can be captured in and around an everyday park setting.

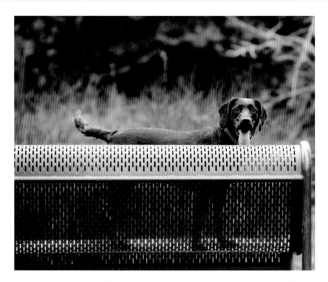

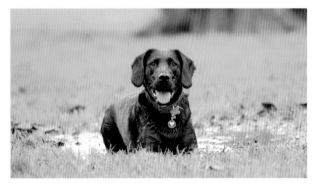

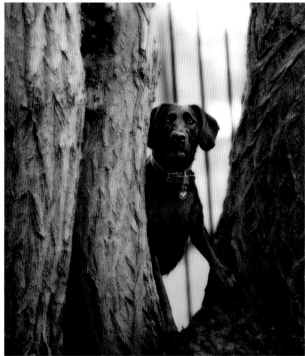

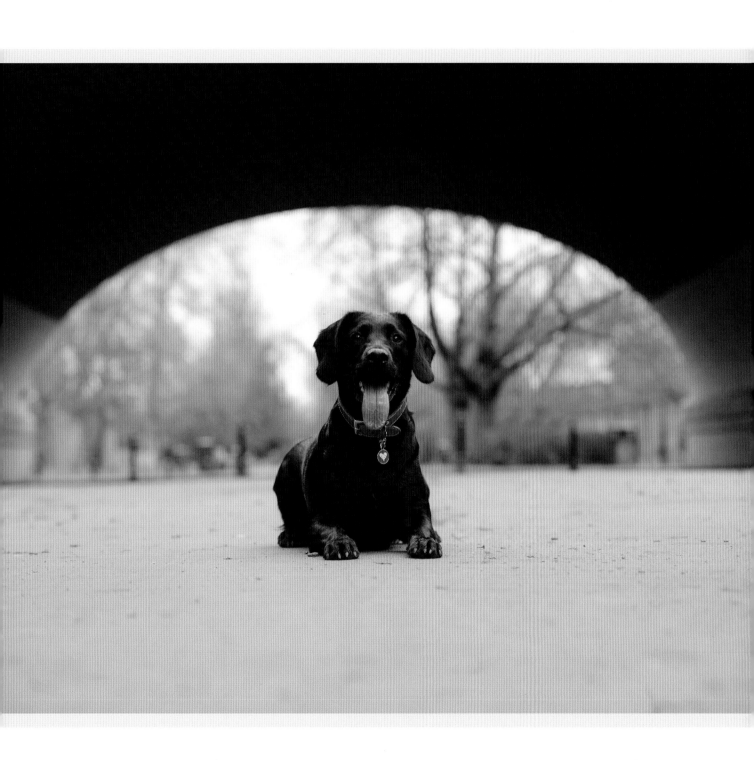

THE PET

The pet *(cont.)*

GUINEA PIG VILLAGE

This guinea pig village represents a very different and difficult shoot. Permission was arranged in advance to enter the guinea pig village and lie horizontally within the enclosure. For this reason protective clothing was necessary since I ended up lying on more than just hay and sawdust. Any sudden movements and the guinea pigs would be startled and dart into the nearest house for safety. This made it imperative to keep absolutely still. The animals were made up of both smooth haired guinea pigs and Abyssinian types with longer, more textured body hair. In either case I found that they would frequently stay in tight groups, especially when nervous, but would slowly break up when food was present and all was calm.

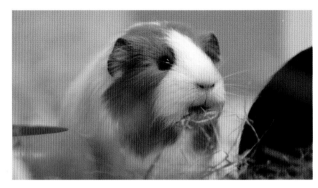

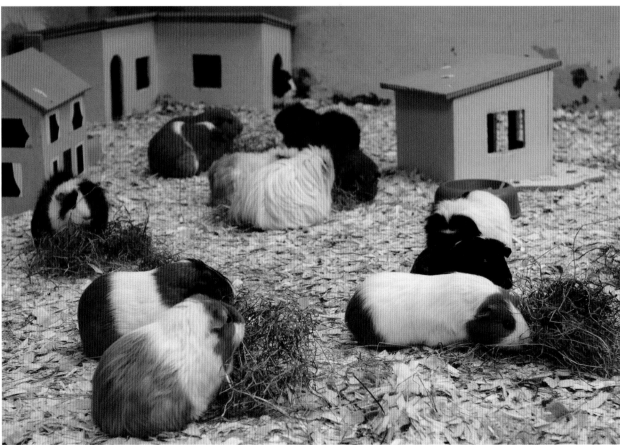

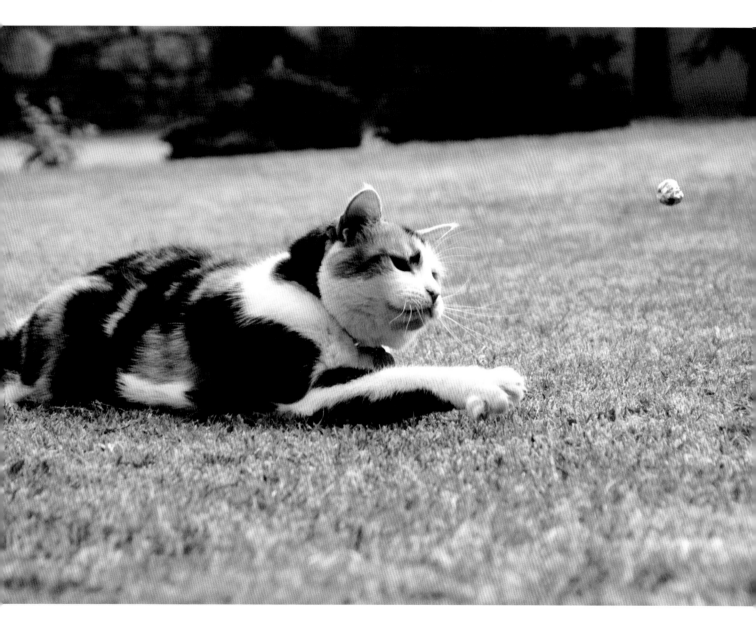

CAT

Cassie, a mixed breed cat, usually greets strangers before disappearing into another room or outside. Like many cats, her love of warmth and the chase of the "imitation mouse" proved too appealing to resist. In this case a ball of silver baking foil was just as appealing.

\mathcal{T}hree classes

I often categorize my pets into one of three classes, obedient, semi-obedient (those with selective hearing), and those I refer to as self-ruling. So which of these three distinct classes does the pet or pets being photographed belong to? You may even find, however, that the chosen subject is capable of displaying a combination of all three classes depending on how hungry they are! Food can switch the class of any one pet in an instant, including even that most self-ruling of pets: the goldfish.

For some pets, the main group that the pet belongs to will be quite obvious. Here are some examples:

Obedient: A highly trained dog performing at a dog show or a police dog performing in its dedicated role is likely to exhibit a high level of obedience thanks to comprehensive training.

Semi-obedient: A "cupboard-love" cat that is perhaps most responsive when food is present. The pet may be strong willed or easily distracted. A good proportion of the dogs I photograph tend to be in the "selective hearing" category too.

Self-ruling: A feral cat, young puppy or pet rat perhaps. Any animal that cannot acknowledge their owner.

When photographing obedient pets you naturally have more time to make decisions on all the choices at your disposal (things like pet pose, background, lighting, and camera settings). This maximizes the shooting time within a session and lets you refine the shots as you progress. Sadly, few pets will fall into this category, but such pets are far easier to work with.

If one trick does not work, then make sure you have a plan B and a plan C if necessary

The semi-obedient pet generally needs more persuasion, either via the use of treats or through other means to persuade the animal into various positions and to gaze at the camera for a split second. This is the time to try one of your silly, inventive noises or noise-makers. Sometimes a fraction of a second is literally the only time that you get, therefore you need to be sure of your shooting angles and confident of your camera's settings before the desired shot is orchestrated. Psychology also plays a key role in persuasion, too and if takes jumping in the air enthusiastically or running in circles to regain the attention of the pet, then that is what you'll have to

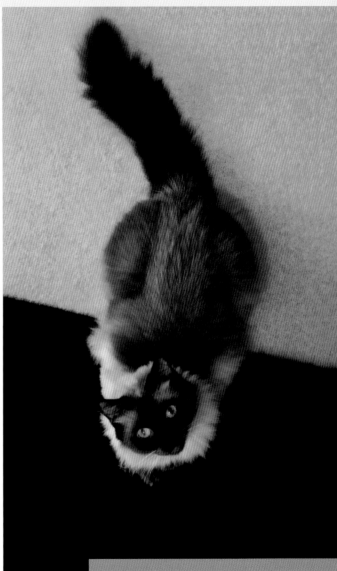

This particular Ragdoll cat shoot was limited to one room. To win the cat's attention I had to make a very strange noise, since it was otherwise proceeding across the room occupying itself and paying me little heed.

do. You have to put aside any sense of shame in pet photography, since there is always the possibility a distant observer will see your antics without noticing the intended audience. That nagging doubt shouldn't stop you trying different tricks until you get what you are looking for: the pet's attention.

With self-ruling pets, you save a fortune on gym membership, pursuing a dog or cat all afternoon. Many cats frequently fall into this category and disappear unannounced, interested only in their own agenda. The key to photographing this group of pets is to look for predictive cycles of behavior and position yourself accordingly as you wait patiently. It can be very much a stalk and shoot strategy that needs to be adopted. For instance, some largely self-ruling dogs will disappear away from their handlers immediately in a wide open space such as a beach or parkland. Their return is usually at high speed before they head off again. In such a situation I'd rather capture the natural character of the dog at high speed than fight a losing battle by attempting a shot of a dog sitting still or standing for a breed profile-style shot. However, if this is the image that a client wants, then your only option may be to photograph the dog with its leash on and later clone it out in your photo-editing software.

Hence the shooting strategy for each of these three groups is slightly different and will be touched upon further in the next few chapters of the book.

Right: The well trained and obedient Border Collie named "Fly" eagerly awaits its owner's next instruction and exhibited an extremely high level of obedience.

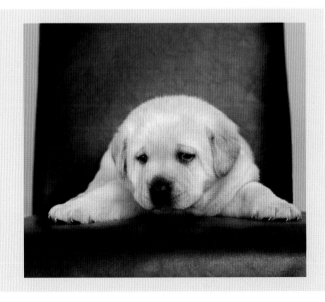

Left: This largely self-ruling Labrador puppy resisted little for a simple portrait image as a state of tiredness overcame its playful nature.

\mathscr{P}hotographing pets

As has already been noted, for any given scenario and subject your potential shooting time will vary, depending on factors such as age, obedience, and the fitness of the pet concerned. For any pet photography session there is usually what I refer to as the "magical shooting time." This represents your optimum shooting time, when the pet is most responsive and the composition and lighting seem to be working for you.

It can be extremely disappointing if this magical time occurs right at the start of the session if you haven't yet checked your camera settings, leaving you with a batch of great poses which aren't properly exposed. With this in mind, your first task on any assignment should be to adjust your camera to produce the optimum exposure. For those photographers that have not yet mastered shooting manually, you can either trust the camera's

automatic modes or, better still, switch to shooting in either shutter speed priority or aperture priority mode, both of which you'll find on any decent compact and all SLR cameras.

These modes will also typically offer the option of a manual override in the form of the exposure compensation feature. If you find that your test exposures are consistently under or over exposed in a given location, you can always use it to correct the problem. My personal preference is to shoot in manual exposure mode, and make fine tweaks to the exposure as the lighting or location changes. When shooting manually, you must be conscious of shutter speed, aperture size, and ISO value, all of which you can change. Key considerations in pet photography are ensuring a shutter speed high enough to freeze any motion and a depth of field that is adequate to retain sharpness in just those elements that are necessary for the image to be a success.

"Fly" the Border Collie running at speed yet still finding a moment to cast a glance at its owner. Shooting data: ƒ3.6, ISO 800, 1/640 sec, 180 mm focal length.

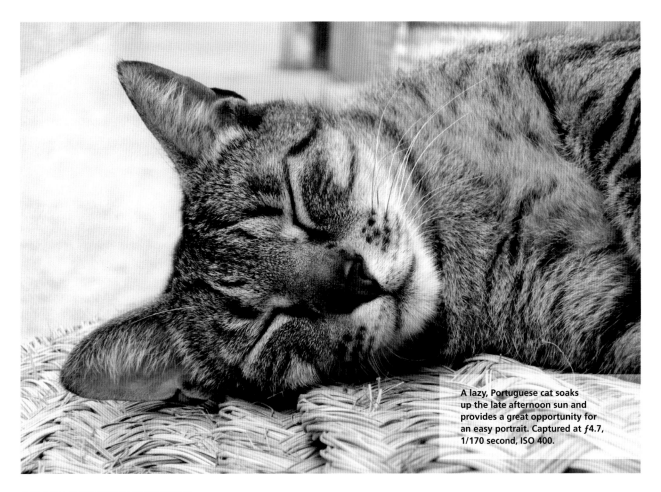

A lazy, Portuguese cat soaks up the late afternoon sun and provides a great opportunity for an easy portrait. Captured at *f*4.7, 1/170 second, ISO 400.

CAMERAS SETTINGS EXPANDED.

Just before we get to the pet, let us finally examine our camera equipment. If you find the exposure and settings display on your camera reads like a foreign language, or is only semi-comprehensible, then here's your chance to brush up. The scope of this book prevents us delving into a full documentary on how to obtain an accurate exposure, or how to manipulate your own compact or digital SLR camera in every situation—there are many excellent books written solely on such subjects, as well as the manuals that are supplied with your equipment. That said, a knowledge of how shutter speed, aperture, and ISO sensitivity are related is essential to creative pet photography, so it's worth quickly going over the key points here. If you haven't switched away from the automatic modes before, I hope that the following encourages you to, and in doing so dramatically improves your photography.

Shutter Speed: the length of time that the shutter is open.
Your shutter speed needs to be open long enough to achieve a correct exposure on the pet. Too short a shutter speed and the image will be underexposed (not enough light reaches the sensor); too long and the image will be overexposed. Overexposure manifests as detail lost from the lighter colored areas, for example white and gray hairs becoming one indistinguishable mass.

A wide aperture can also lead to over-exposure, but only shutter speed affects how much motion blur can occur. If the subject moves quickly, like a horse galloping, a high shutter speed is need to freeze the movement, but you risk underexposure. If the horse is standing still, a slower speed may be used. So if you select the shutter speed to match the motion, what can you do about the light?

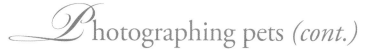

Aperture: This is the mechanical "iris" inside the lens of the camera that opens and closes to varying degrees, controlling the amount of light that is allowed to pass through to the sensor.

The aperture offers an alternative to changing the shutter speed when you are trying to select the correct exposure. A wider aperture allows more light through so, to avoid underexposing a shot with a fast shutter speed you can widen the aperture. Aperture settings are measured in *f* stops, with smaller numbers representing a wider opening. The flip side of this is altering the aperture affects the depth of field, or how much of a scene is sharply in focus. For example, you are presented with a cat lying on top of a shed looking inquisitive. The angle of view behind the cat presents a lot of old junk on the roof of a neighboring shed. A shallow (or short) depth of field would make the background fall out of focus, turning an ugly mess into a pleasing soft background for your subject.

ISO: in digital terms, this refers to the light sensitivity of the camera's sensor.

In general terms lower ISO values (like ISO 80 or ISO 100) yield far less noise — the digital equivalent of film grain — than higher ISO values (ISO 1600 or above). Hence larger prints can be produced without noticeable noise from images shot at lower ISO values.

Why not use the lowest ISO value all the time for pet photography to achieve the higher quality print? Low ISO values, need more light (longer shutter speeds or a wider apertures) to achieve the correct exposure. Hence, the resulting shutter speed from selecting a low ISO value at a given aperture may be too slow to freeze the motion of the pet or indeed to handhold the camera. I usually push up the ISO to enable the higher shutter speeds that are so often necessary in the field of pet photography without changing my aperture (and thus depth of field). Some of the latest professional digital SLR cameras are capable of producing images at extremely high ISO values, up to ISO 6400.

So, shutter speed, ISO, and aperture are all inextricably linked in defining an exposure. In strong lighting there is far greater freedom to experiment with wide and narrow apertures, slow and faster shutter speeds, differing focal lengths, and ISO values. In dimly lit environments, many of these decisions are made for you since the camera will be pushed to its limits to achieve a correct exposure.

One trick for beginners is to use a camera's automatic shooting modes (portrait, action, and the like), then, when you look at the

SHUTTER SPEEDS TABLE

Shutter Speed (minimum values)	Possible Pet Photograph – Notes
1/15 second	Image stabilized lens, handheld for sleeping, static, pet (required good hand holding technique)
1/60 second	Static or sleeping pet
1/160 second	Fidgety pet that is mostly static
1/250 second	Slowest possible shutter speed for pet moving directly towards the camera
1/400 second	Recommended minimum shutter speed for freezing slow moving pet (left to right from camera position)
1/600 second	Good shutter speed for freezing the motion of a moderately fast dog, for example a Terrier grouping
1/800 second	Minimum speed for faster dogs and galloping horses.
1/1000 second and greater	The fastest of dogs, like greyhounds, and other fast moving pets.

The above values are only guide values.

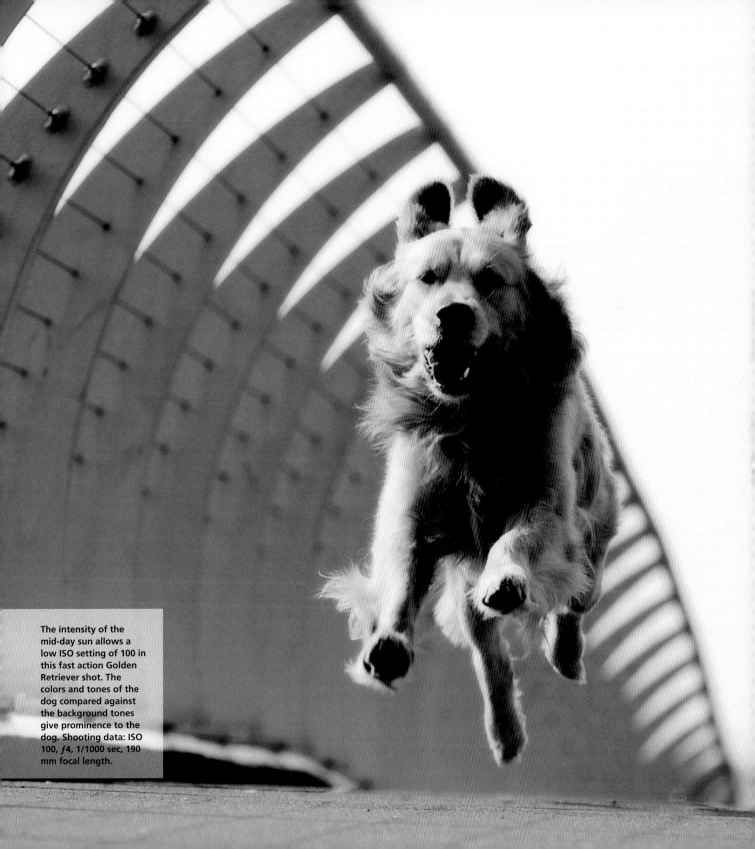

The intensity of the
mid-day sun allows a
low ISO setting of 100 in
this fast action Golden
Retriever shot. The
colors and tones of the
dog compared against
the background tones
give prominence to the
dog. Shooting data: ISO
100, ƒ4, 1/1000 sec, 190
mm focal length.

The "concentrating cat" illuminated by two windows—one at eye level facing the cat and a second positioned above and behind the cat (right hand side) provides both frontal lighting and rim lighting (as observed on the cat's ears). The shallow depth of field is achieved by using an aperture setting of f2.8.

images on your computer, look the EXIF data that is captured as you shoot. This allows you to learn from the camera's decisions about ISO, aperture, and shutter speed which will all be there, as well as other data. Another idea is to use shutter priority together with the table on page 52. It shows the ideal speeds to capture a particular pet without the image exhibiting motion blur. However, if motion is to be documented in an image, say using a camera panning technique then the following guide should be ignored.

Depth of Field: This is the amount of distance between the nearest and furthest points that appears to be acceptably sharp in focus. The depth of field of a lens extends 1/3 in front and 2/3 behind the selected point of focus.
Why is this important? Take two dogs, a Pug and a Greyhound. The Pug has a relatively squashed-looking face and smaller nose while the Greyhound has a longer nose and less rounded facial appearance. If the camera is focused on the face of the Pug, a relatively wide aperture of ƒ4 should easily cover the outer tip of the nose and the eyes sockets since the face is quite flat. However, the Greyhound's longer protruding nose, depending on the exact point of camera focus, may extend beyond the depth of field, so either the nose or eyes—but not both—are in sharp focus. Depth of field can be increased three ways:

a) Use wider focal lengths (or do not zoom in). A 24 mm lens will give a greater depth of field at a given camera to subject distance than an 85 mm focal length at the same positions.

b) The closer the camera is to the subject the less the depth of field. Hence, moving a few inches or feet backwards from your chosen pet may give you the depth of field that is needed.

c) Use a smaller camera aperture (often referred to as an ƒ stop). ƒ2.8 is considered a wide aperture, ƒ16 or ƒ22 are considered small apertures. The drawback of smaller apertures in pet photography is that they require longer shutter speeds (or higher ISO) to achieve the correct exposure.

White Balance
On the vast majority of cameras on the marketplace today (whether budget compact cameras, mid-range prosumer models, or digital SLRs) you will find a white balance feature. This usually gives you the option to pick between automatic, various presets based on lighting conditions (sunny, shade, cloudy, flash, fluorescent or tungsten) and possibly a manual option. It is definitely worth becoming familiar with this particular feature to allow you to be sure your images have accurate colors. Natural light at different times of the day or artificial light can be measured by its color temperature using the Kelvin scale.

Auto white balance will do its best to correctly assess the color temperature of the existing lighting and will generally perform better outdoors using the natural available light than indoors where

Above: A tungsten white balance on the above dog image gives an entirely different "blue" appearance to the actual scene that was observed through the human eye. The blurred background is achieve by both the wide aperture setting on the camera and the distance behind the dog to the distant buildings. Shooting data: ƒ2.8, ISO 400, 117 mm focal length, 1/500 sec shutter speed, white balance: tungsten.

fluorescent, tungsten, halogen, or even mixed lighting may be contributing to the overall illumination. On an outdoor shoot where the pet photography may be spanning several localities under broadly similar lighting, it may not be practical to perform custom white balance measurements or vary the preset values at each stopping point. However, when photographing indoors, much greater attention should be paid to obtaining an accurate white balance.

Handler's rules

In any photo shoot, you'll need to establish with the handler which of you will be giving the commands, or making the necessary noises or other signals to the pet. Without this clearly set out, the pet may well become confused by simultaneous signals and end up looking in the wrong direction. Here are some guidelines that I follow to keep things running smoothly.

a) Keep food treats or other attractions like toys out of sight until needed. If you're trying to capture a simple portrait showing the animal looking relaxed you certainly won't want to create unnecessary excitement, and exposing your armory early will diminish the impact when you need it.

b) Ensure that the handler is aware of the light source and direction, so they don't end up blocking it. If they are in front of a window, their shadow may cut across the pet, for example.

c) If you are photographing from a low angle, make sure that the handler mirrors your own height and, if possible, is situated behind you.

You may be at ground level to cajole the pet or pets into to looking directly at the camera. If the handler is standing tall and off to the side, the gaze of the pet may well switch from you to the general direction of the handler. Some dogs—mostly Border Collies in my own experience—can be fixated on their handler in confined spaces and look to their handler for reassurance or their next command.

d) Unless you're trying to include the owner or handler, make sure that they're not in the line of fire, since this will inevitably result in them appearing in shot behind the pet itself and may require extensive post processing to remove. In some photographs, it may be preferable to have part of the owner in the image to show the association between pet and handler, but it is better to do this by design rather than by accident.

e) If the pet is a dog or cat it is important to decide in advance who is to give the commands (or at least the sound incentives), when they are required to gain the attention of the pet. You should not underestimate the handler's role in perhaps being able to gain the attention of the pet. Although you should know your own persuasive tricks, you must remember that the handler will know all the magic words that can gain the attention of their particular pet at the desired time.

f) Demonstrate to the handler in advance how to hold a leash attached to a dog for the purpose of a photograph (if photographing a dog on a lead for safety/practical reasons). See the section on Dog Portraits section for instructions.

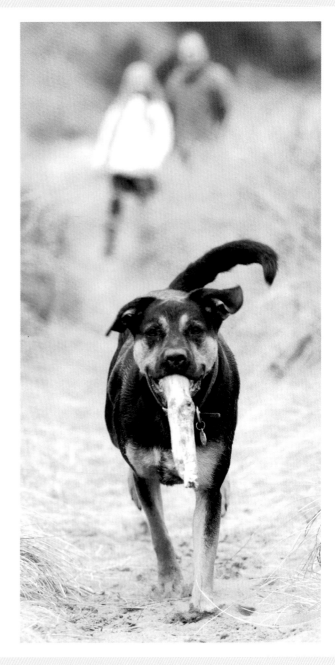

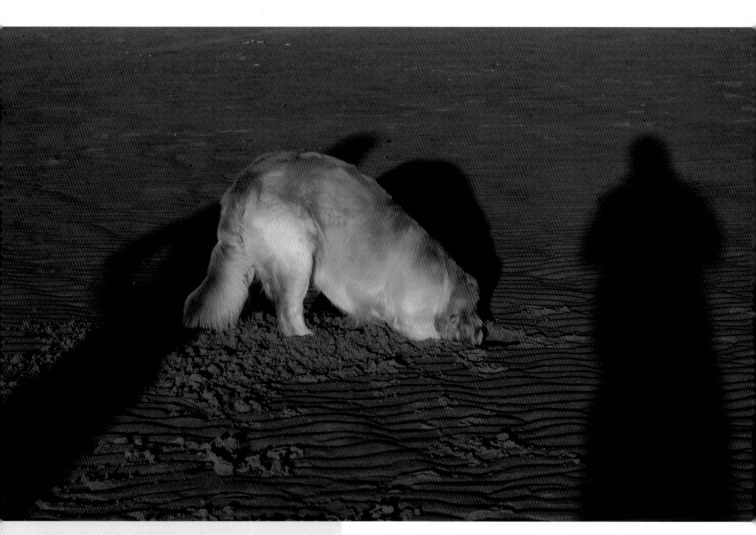

Above: The position of the handler and photographer in this scene results in unwanted shadows that cut across the dog's position. The back end of the dog also appears far more prominent in the image than the interesting part of the scene, i.e. the dog digging in the sand.

Left: In this image the owners are behind the dog and just out of the "line of fire." They are sufficiently blurred to the extent that the association between dog and owners could be inferred from the scene.

The handler may well know the magic words that can gain their pet's attention at the desired time

Pet photography styles

There are generally four categories of pet photography. These categories are not set in stone and there can be cross-over between them.

EVENT PHOTOGRAPHY

In event photography the primary objective is to capture the event as it happens. Like sports photography there is little interference on the part of the photographer with either pet or handler, or the surrounding environment. For example, many event photographers, such as those covering a dog agility event, or shooting an equestrian event are focussed on achieving the perfect animal image of a dog sprinting or horse jumping. Their ultimate goal may be for sales purposes to the handler of the animal. Therefore the timing of such images is crucial since the images will be critiqued by the animal handler in terms of animal posture. They may already have a collection of images from previous events and will therefore only make a purchase on the basis that the image is very different to any previous photograph. Event pet photography, with the exception of show events, typically involves shooting at higher shutter speeds than the other categories of pet photography. Photographers will either be designated to a specific area or have the freedom to choose their own shooting location, but will probably need to keep a distance (so bring a telephoto lens). In cases where overhead lighting is not the dominant light source, they will mostly opt for a shooting angle that exhibits frontal or 45 degree lighting to clearly show the detail, colors, and markings of the pet. Side lighting or

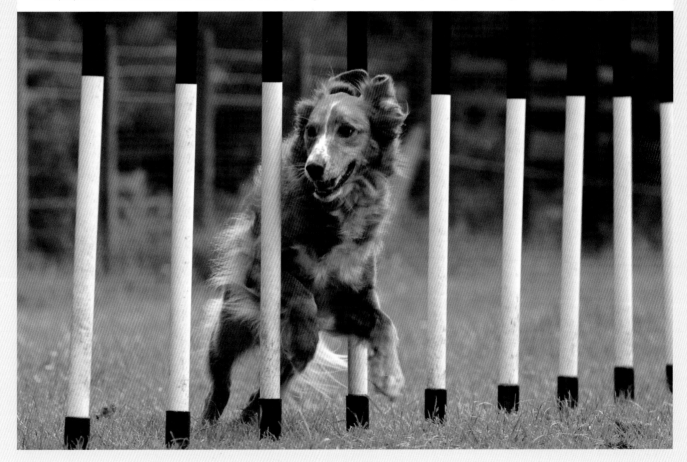

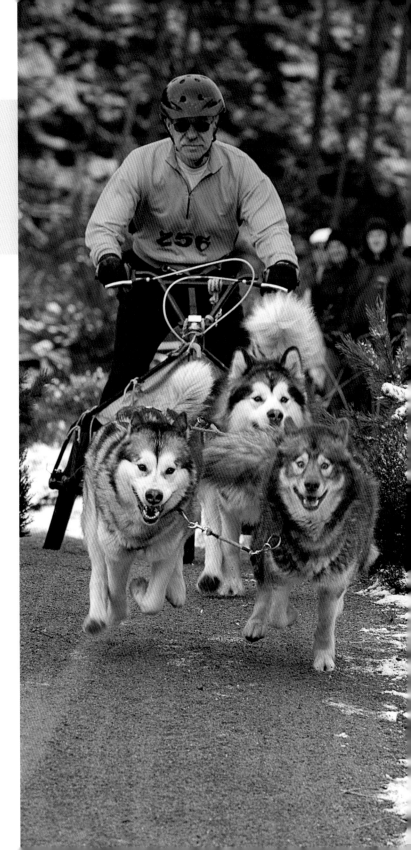

Left: This image demonstrates the weave, often seen at dog agility events. Precision focusing is necessary to ensure that the dog is in sharp focus, rather than one of the poles making up the weave line.

Right: Three Siberian Huskies pull along the rider at the Siberian Husky Championships in Aviemore, Scotland. In this image it was critical that all three dogs' heads were clearly visible in the photograph, making it hard to pick the right moment to shoot.

back-lighting may produce a more artistic image, with dramatic lighting, but pet handlers at such events generally prefer to buy a clearly visible record of their pet in action rather than a rim-lit silhouette where their pet is barely recognizable. There are many compromises that need to be made with event photography since an area may have people and other distractive elements in a scene around a ring. Colored marquees, vehicles, and caravans may be ever present at an outdoor dog agility event. In strong light, opting for a shallower depth of field by a wide aperture setting may assist in blurring out such elements.

RECORD PHOTOGRAPHY

Record pet photography is typically associated with either studio or environmental pet portraiture. The pet will be positioned, persuaded, or instructed into a designated area (or set), and a series of images taken to portray the character and physical characteristics of the pet. The objective is for the image to portray an accurate representation of the pet, its habits, or key features. In a set the area can be very limited (especially if the animals in question are hamsters) up to relatively expansive if, for example, constructed in the studio for a group of dogs. In the studio the more obedient the pet or pets are, the more opportunities there may be for varied lighting set-ups, typically associated with classic portrait photography. Some studio environments may well appear similar in appearance to a veterinary surgery from the pet's eyes (bright lighting, white walls) and hence not trigger the most favorable reaction. A significant proportion of dogs or cats entering such an environment will also not readily sit still, especially if other pets or animals have just been photographed in the same area and have left their scent behind. For a clean record photograph lighting intensity ratios are often kept at 1:1 (two lights on either side of the subject are set to the same level of brightness). In the most standard of setups these should be positioned 45 degrees to the left and right of the position in which the animal is placed. A broader definition of record photography might also involve environmental action pet photographs like that of a cat jumping or a horse galloping through water.

BREED PROFILE PHOTOGRAPHY

Breed profile photography is primarily concerned with placing the animal in a position that best documents its show characteristics. For example, at a dog show a handler will position or "stack" their dog to best showcase the dog's confirmation. This may be for an illustrative guide to a particular breed, as a record, a winner of a particular heat, or maybe for an advertisement purpose. A dog breeder may wish to use the image in an advertisement to showcase the "future" parents if they later intend to breed from the dog. Lighting is typically a simple 1:1 or frontal arrangement to provide good detail in the animal. Again, like event photography, crucial attention will be paid by the handler to the leg, body, and head position. It is certainly worth speaking to dog handlers who show a particular breed of dog what is acceptable and what is not in terms of a dog's standing position. Any of the specialist dog, cat, or horse books will also typically emphasize the specific breed characteristics that the animal is recognized by.

Above: This image was captured at a stallion grading horse event. The stance and posture of the horse is being assessed by one of the event's judges. Extreme care must be taken when in the ring with such large animals.

Right: This curious rabbit was more than eager to sniff the overhead camera and the wide-angle lens, and finishing in Adobe Photoshop has resulted in a less than common image of a rabbit. Shooting data: *f*3.2, ISO 200, 1/1600 sec.

Far right: "Your dinner's ready." The look of the dog's face in this action image immediately make this a quirky picture that could provide great amusement and raise many a smile from those observing the photograph. Shooting data, *f*2.8, ISO 800, 1/500 sec.

CREATIVE ART PET PHOTOGRAPHY

In creative art pet photography, unlike the others categories, there are no rules that need to be as strictly adhered to. The photographer has the freedom to use natural and/or artificial lighting, move objects or furnishings at will (permission granted of course), and does not necessarily have to opt for front, side, or 45 degree lighting as the dominant light source. The resulting images may be enhanced and manipulated far more in an image editing tool like Adobe Photoshop than the other categories.

This type of photography can either be studio based or be conducted on location, and can happily accommodate the use of specialist photography lenses such as fisheye lenses. Some of the quirkier pet calendar companies often use fisheye or extremely wide angle lenses in the studio, resulting in overly distorted, enlarged heads (the closest part of the pet to the camera). An inspirational photographer in this area is Tim Flach, who shoots all kinds of animals (not just pets) and is, in my opinion, one of the masters at this type of photography. A great deal of patience, time, and creative vision is needed to produce such images, but it is something you need to aspire to.

QUIRKY PET PORTRAITS

I like to think of quirky pet portraiture as those images that don't so much reflect the accurate appearance of a particular pet as its characteristics. It is another opportunity to reach for your extreme wide angle or fisheye lens, for example.

These pictures may be taken by chance, for example capturing a startled look in the eyes of a pet, an unusual body position, or the more traditional shot of tongue stretched out or touching the animal's nose. Some pets can amazingly perform tricks on the command of their handler, either with or without props, and it is always worth asking the handler if a particular pet has any such talents. They often make great quirky pet portraits and the handler will respond enjoy these moments being recorded.

One strategy in this area is to look for less common views. Try assuming an extremely low shooting position, pointing upwards at the pet, or conversely adopt a high angle and look down. Experimenting in an unusual environment with a particular pet (assuming it's still safe) is likely to produce a more unusual picture which will catch attention, too. Why not sit a pet mouse on a serving plate in the middle of a table set for dinner?

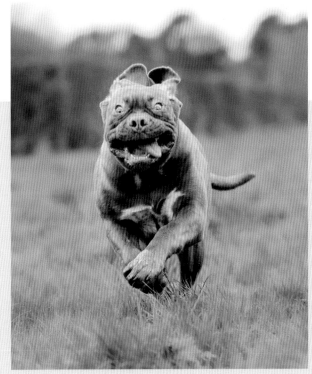

*U*se of artificial lighting

In situations where your environment is restricted and perhaps the illumination is limited, a high ISO value may not be enough to sufficiently freeze the action or even allow you to handhold the camera. Maximum ISO values will likely be too noisy, so a better alternative is to turn to artificial light, but what kind?

The use of flash photography should only be done with caution

Other situations which call for a little help include those where the existing direction of light may create shadow pockets on the pet when such areas would look better illuminated; for example pronounced eye brows may obstruct a light source and result in lost catchlights (the sparkle of reflected light) in the eyes of a pet. In such circumstances you have the option of either moving the pet so there is a greater chance of the reflection of the emitted visible light being caught in the eyes, or to boost the existing illumination with supplementary lighting such as flash or a powerful continuous light source that is placed strategically in the room. There could be a whole book devoted to the use of flash photography and additional lighting methodologies and it is certainly recommended to devote some time in learning at least the basics of flash photography. If

your budget extends to using a continuous light source then it is often preferable to position any light so it's directed off a white wall or ceiling. Alternatively you may supplement your illumination with flash photography, but direct on-camera flash is to be avoided unless you have no other means of modifying your light.

This is because direct on-camera flash is harsh, giving high contrast lighting that may illuminate your subject and cast the background into darkness if used incorrectly. A slower shutter speed is advisable when using flash in a non studio environment since it will enable more of the ambient light to be recorded in an image and thereby produce a less harsh image than when your subject is illuminated directly and the background is cast into darkness.

Some compact cameras will not allow any versatility with their integrated flash systems. On a digital SLR camera, however, you should find a hot shoe, positioned on the top of the camera, which facilitates adding a flash unit which can often be swiveled so the light is bounced from a nearby wall or ceiling, minimizing harshness. The resulting light will be softer, more flattering and should avoid the color tints in the retina of the pet's eyes. When bouncing light, be aware of possible color casts picked up from the walls or ceiling if they are not white.

There are also many flash accessories on the market that have been designed to be both extremely portable and to soften the

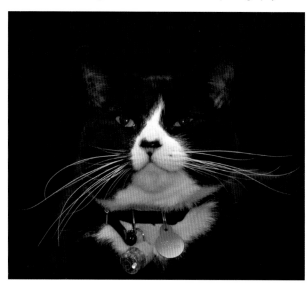

Below: Many diffusers are on the marketplace, all with different light softening characteristics.

Left: "Nancy" the black and white cat retains sufficient patience for a simple head shot though the use of a supplementary flash highlights the problem of "green eye."

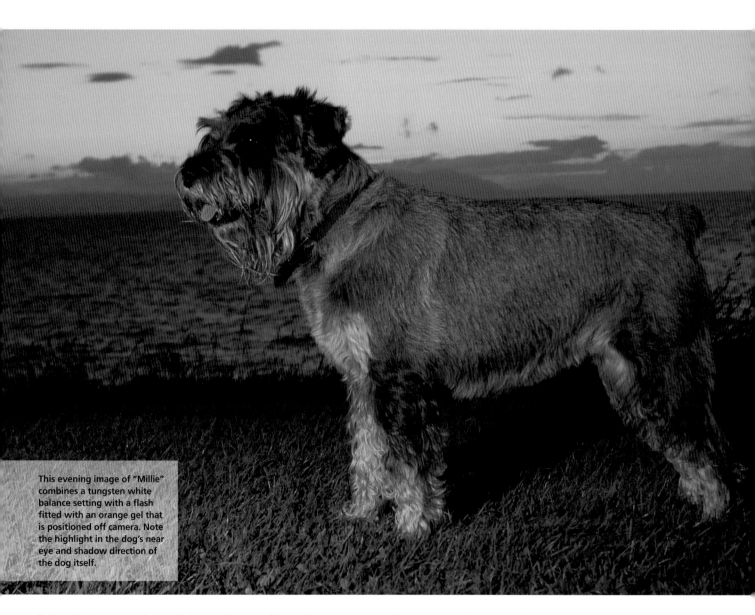

This evening image of "Millie" combines a tungsten white balance setting with a flash fitted with an orange gel that is positioned off camera. Note the highlight in the dog's near eye and shadow direction of the dog itself.

light emitted. Such products include portable minisoftboxes, light spheres, and Stofen's light diffusers. These can be extremely useful for pet photography.

This section cannot be finished without a note of warning though. Flash photography should not used without caution. For some animals, including stabled horses as well as the more usual suspects, its use is to be strongly avoided on the grounds that it can easily scare and startle animals. The same rule may apply to rescued animals that have recently been rehomed and are extremely wary of strangers. If you are unsure, it may be worth firing a burst of flash at some distance from the pet and seeing its reaction at a safe distance. The handler may be able to give you some clues or direction as to how the pet may react. In my opinion the welfare of the pet should never suffer at the expense of good photography.

Camera angles for pet portraiture

A key question that I'm often asked is what the best angle is for photographing pets.

There is no definitive right or wrong answer, but my preferred shooting angle for dogs and cats is low down on the ground at the pet's eye level. Before lying down you may wish to check the ground first for any deposits that you'd rather not have stuck to your clothes. As was suggested under "quirky pet photography style," you may alternatively wish to accentuate the diminutive nature of a particular pet by shooting downward from a higher angle. This angle may also be worthwhile if the background behind the dog is particularly cluttered and would otherwise detract from the pet portrait.

Alternatively, with a larger and powerful dog such as a Weimeraner, shooting from a low angle upwards to the dog or placing the dog on a raised elevation may accentuate the dog's apparent strength and guarding characteristics. Old clothes and even waterproofs may be essential if you are to keep your options open as the shoot unfolds. I've found myself climbing walls in the past (in order to follow a cat) and have returned home with muddy pants from occasions where I've had to quickly drop to the ground to get an angle that suddenly appeals to the eye. Your options can be limited by anything from a cage to a cat's reluctance to leave it's favorite spot once in position.

You may wish to emphasize a pet's diminutive nature by shooting from a higher angle

Below: Overhead view of the rabbit on the move could be used to illustrate the particular markings of the pet or its physiology.

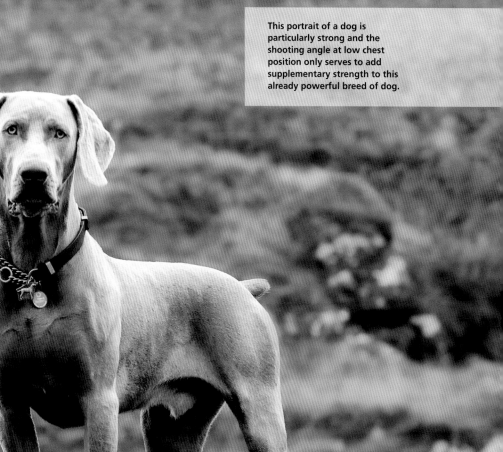

This portrait of a dog is particularly strong and the shooting angle at low chest position only serves to add supplementary strength to this already powerful breed of dog.

*L*ighting angles for pet portraiture

In addition to the shooting angle, there is also the lighting angle to consider. Is your subject best lit from the front, the side (and if so how far to the side), or even behind?

For a group of animals with differing colors, or a standard portrait where the pets have black and white markings I may opt for frontal or 45 degree lighting to make sure there are catchlights in the pet's eyes. If I wanted to document the texture of a particular animals's coat then I'd opt for side lighting which would accentuate such features. Backlighting can create some very artistic looking portraits, and can create some lovely rim lighting or silhouetted images.

It should be remembered, however, that the lighting direction needs to be considered in association with the background scene. Assuming for a moment that the pet is resting, as you move around it to alter the lighting, you will also change what you can see in the background. And, vice versa. If you move to alter the background, the lighting is affected too. It is crucial that you consider both as you compose your shot.

Right: The side lighting in this shot only serves to accentuate the muscularity of the race horse in the low winter sun. This texture would be far less pronounced if the horse (or the light) was turned ninety degrees so that the side of the animal was lit directly. This shot is taken at ƒ4, ISO 400, 1/500 sec.

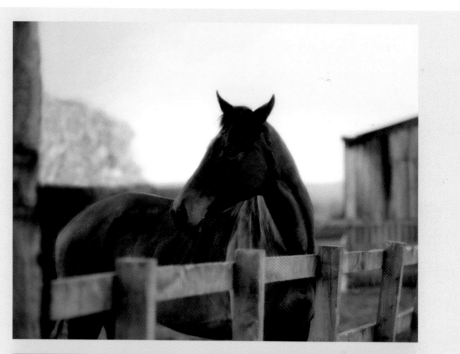

Bottom: Move me if you dare, this shot seems to say. Natural frontal lighting from the main window in the living room was used for this portrait of a Weimaraner that had made itself comfortable on the couch. This shot is taken at ƒ2.8, ISO 800, 1/40 sec.

Opposite: This cocker spaniel dog looks lovingly at its owner (out of frame). Backlighting provides both rim lighting and an element of lens flare that could be removed if desired in post processing. The flare in this case is being used in the composition, so the dog can be centered in the frame without the balance appearing dull; the sun offsets it and keeps things asymmetrical and interesting. This shot is taken at ƒ4.5, ISO 200, 1/1000 sec.

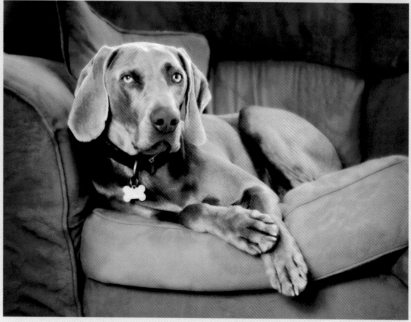

This chapter is dedicated to the individual needs of photographing dogs, cats, horses, and smaller pets. For each of the animals discussed, the creature's behavioral characteristics—and how it might express them through its body language—are revealed, helping you build an insight into what might await you. You will also find some potential strategies that might be employed to gain the attention of the pet and keep the shoot running in the direction you've chosen. Where possible I've also supplied the original camera settings alongside my photography so you can glean some technical hints that might be of use when composing shots in similar conditions.

Pets in detail

uppy portraits

Puppies are both a joy and a challenge to photograph. They are mostly self-ruling as they embark on their journey in life. Depending on their age they may still be with their mother, with the other puppies ready and eager to chew on your shoe laces or departed from the litter and now settled in the family home. Old clothes and perhaps even waterproof trousers are advisable since the youngest puppies will not have finished their toilet training.

Depending on their development puppies will either be sleeping, feeding, or exploring. When in exploring (or playing) mood you will need to react extremely quickly with the camera since they themselves may well find that the camera itself is appealing. On the other hand, if your subject is sleeping there may be a chance to capture some record shots of this stage of their development. To be honest, the exciting opportunities are when puppies are up on their feet and in a state of mischievousness. When you enter the puppies' enclosure you'll find that they start a mad race to greet and welcome their new guest.

On the subject of enclosure, the younger the puppies, the more likely they are to be confined to a specific area, so in all likelihood space will be limited. In small enclosures you will potentially have at least three problems.

The first is the limited shooting distance from camera to subject. This will inevitably be restricted which will consequently give you a limited depth of field so take one or two test shots and decide if you have enough sharpness at your chosen aperture. Using wider angled lenses or avoiding zoom will certainly give you a greater depth of field before you are forced to widen the aperture.

The second common problem is the lack of available natural light. Puppies will rarely be given the best room in the house for lighting and photography. They will more commonly be residing in the most practical room for cleaning up mess; a back quarter of an outer building or a room that is next on the list to be decorated. This means the desired shutter speeds and depth of field combinations may be impossible unless your camera is a top end professional model capable of shooting at ISO 6400 with acceptable results. For the vast majority of photographers who don't have the privilege of being able to shoot at such high ISO's and retain the image quality, the use of artificial lighting may be the only practical answer. The breeder or puppy handler may allow you to use a different space temporarily, so it is certainly worth asking.

The third problem that you might run into is some sort of heat lamp that may be in the center of the room, hovering high and casting a red glow over the puppies. Its use is fundamental

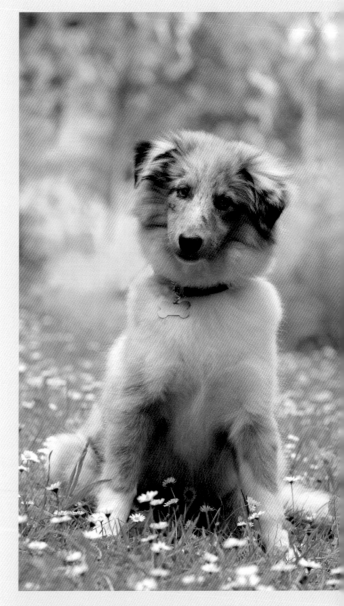

Above: Training began early for this Shetland Collie puppy that understood the basic "sit stay" command. Of all the portraits that you take during the lifetime of a dog, you'll find later looking back that there are never enough photographs of these early "puppy" days that pass by so quickly.

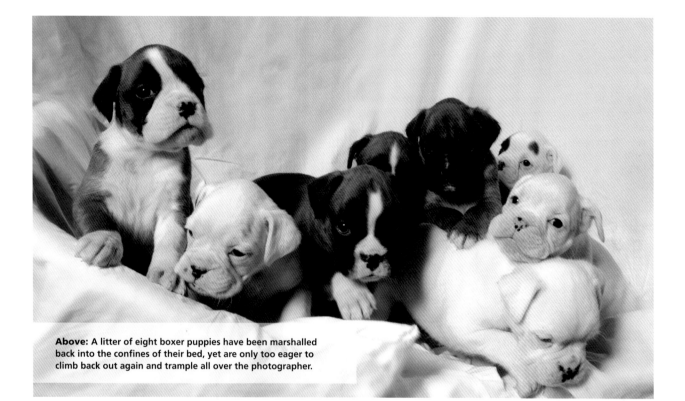

Above: A litter of eight boxer puppies have been marshalled back into the confines of their bed, yet are only too eager to climb back out again and trample all over the photographer.

in the welfare of the puppies, but unless corrected via a preset or custom white balance at the time this will give you further work to accomplish during post processing.

Unless you want the image to portray a particular appearance or intend to convert the images to black and white anyway, you will be able to set a custom white balance by placing a sheet of white or gray paper, known as the "neutral target," under the same lighting conditions as the puppies will be, then selecting the custom white balance target mode (or similar) from the menu.

PUPPY TACTICS

My technique, if I'm photographing young puppies in a restrictive enclosure, is to initially greet the litter of puppies, becoming accustomed to their world as they get used to me. If you've done your location reconnaissance properly you should also be aware of the lighting and potential shooting angles. Ensure your camera is within easy reach of you, but out of paw-reach. Observe their patterns of walking and wobbling, and after a period of time, you may find that the initial interest in you has waned slightly, with some members of the litter reverting to chewing the other

ears of their brothers and sisters, or trying to keep warm. It is at this point that I'd typically aim to start photography. There is no point in setting your list of desired shots in stone. Shoot with an open mind. The use of one of your silly noises may temporarily halt the antics of the puppies and allow you to capture one or two portraits as they look inquisitively in your direction before charging at you. The handler may also prove useful in shepherding and scooping puppies back and forth to the optimum spot.

> Photograph with an open mind rather than a set in stone list of desired images.

The animal's energetic pulses will soon wane, however, as a state of sleepiness takes over. During such times there is the scope for some sleepy portraits and you can work at much slower shutter speeds. Oh and one last thing: before you leave the enclosure, ensure that both your shoe laces are still intact!

Dog portraits

For the purpose of this section, lets consider the term "dog portrait" to mean any static, directed shot, whether it has taken place in the studio or outdoors on location. The pose or stance of the dog has been carefully considered in the image and this may have occurred either naturally or via intervention on the part of the photographer or handler. You'll need to ask yourself a series of questions, many of which can equally apply to other pets too. The answers to these questions will help dictate the shot:

Some dogs often do not necessarily look their best towards the end of a session

Is the portrait going to be the full dog, predominantly head and shoulders, or a small portion of the dog, such as just its face or an eye and ear?

Is the dog going to be photographed in profile view (side on) or directly facing the camera?

Does the dog have a better side? (The dog may have the scars from a former operation or facial wounds that the handler would prefer not to show).

When not in the studio, where could the dog be positioned taking into consideration the light, its quality and direction, the background, the dog's colors and other potential distractions?

Is the intention of the pet portrait for the dog to be dry and clean or muddy and ragged?

Are you aiming for the tongue to be in or hanging out of its mouth?

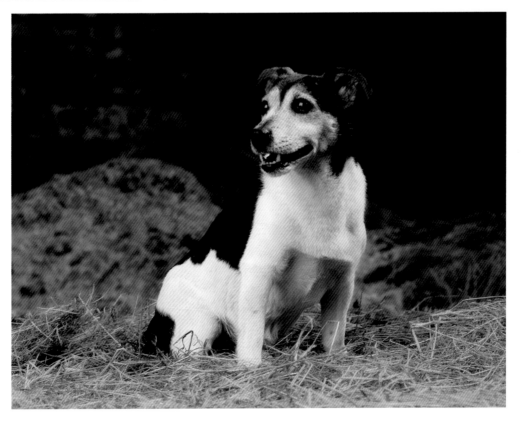

Left: This Jack Russell was more than at home when commanded to sit on a bale of hay in an old barn.

Opposite, top left: By assuming a low camera position (at the dog's chest or eye level) your dog portraits will in general be far stronger.

Opposite, top right: Don't just shoot the whole of the dog; move in closer, or zoom for head/shoulder portraits too. This image was processed into a sepia-like tone in Photoshop.

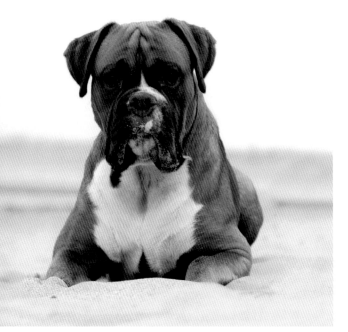

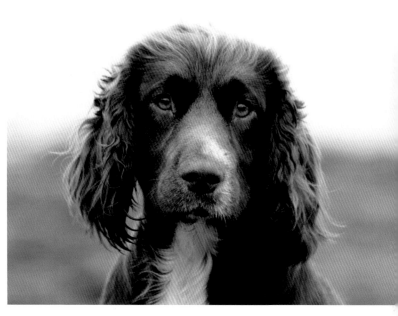

Will the dog take commands from its handler or the photographer "off the lead?" In other words, will it simply move away from the preferred spot when released from collar and leash?

When photographing obedient dogs, it is are obviously much easier to take the desired image, but this can also be fine-tuned, by repeating the shot again and introducing subtle variations. A standing dog at 45 degrees to the camera having its own portrait taken may also be in a happy state of mind and wagging its tail. By photographing a number of frames in succession, there will inevitably one frame that looks better than another by the position and angle of the tail.

There have been some dogs where I have wondered if they will ever stop moving, even for a second. This is usually due to being in a state of excitement, nervousness, or being affected by some other factor such as the dog thinking it may be put back on the leash and returned home. In such cases your strategy may be to either wait until the dog has tired or photograph the dog on the leash and clone the lead out of the image later in your photo-editing software. It can be beneficial to opt for the latter approach since a tired dog may also be a wet and muddy dog if it has been given the freedom to roam. Secondly, some dogs have drools of saliva from exercise and adventure and often do not necessarily look their best towards the end of a session.

Right: The brown tones of this Dogue de Bordeaux dog are complimented by the turquoise door in the background resulting in the dog easily standing out from the backdrop.

*L*eash holding techniques

For several reasons it may be necessary to keep a dog on its leash for a portrait. As I've already mentioned, the dog's obedience level might be one of them, though it is by no means the only possibility. Good behavior may quickly change in the presence of other animals, or perhaps local dangers, even park rules, may force the use of a leash.

A thin coil-leash is much easier to remove in post production than a thicker leash, and a contrasting color helps too

The handler will need to be given direction as to how to hold the leash. Ideally, the handler will be stood to one side of the dog as far away as practical. The leash must be held above the top of the dog's back, yet not to be pulled too tightly. Keeping the leash taught like this will allow it to be cloned out much more easily than if it drooping across and in front of the dog. That said, the other key aspect of holding a leash is that it must not be pulled too tightly. Otherwise, after the leash is cloned out, the collar will look as though it is being pulled by some mysterious force.

Of the various types of leash on the market, the retractable wire leashes are the most suitable for photographing dogs for a number of reasons. Firstly, they have a length that may be modified from just a few inches, to the length of the coil—generally anything up to 18 ft (6 meters). The lengthier distance can enable the handler or owner to be well away from the dog, and nicely out of shot. The relative thinness of the coil (in comparison to fabric, metal, or leather leash) makes it much easier to remove in post production. If the leash extends across part of the front of the animal in the photograph there is also less fur to clone back than some of the thicker leashes.

Some dogs may have a leash attached to a harness and in such cases it may be worth asking the owner if the harness can be removed.

Left: A good leash position illustrated. The head of the dog hides the leash behind the dog, with the visible portion of the leash easily removed in post processing. The uniformity of the blue background behind the leash makes this even easier.

Right: The black leash against the black door facilitates the task of cloning out the leash in this rescue dog. This Bichon Frise is also easily visible against the darker doors.

Below: This image shows poor leash handling since the lead cuts across the dog and the collar is being pulled. The image can still be corrected in Photoshop, but it will end up taking more time. In this case the stretched collar needs to be removed too.

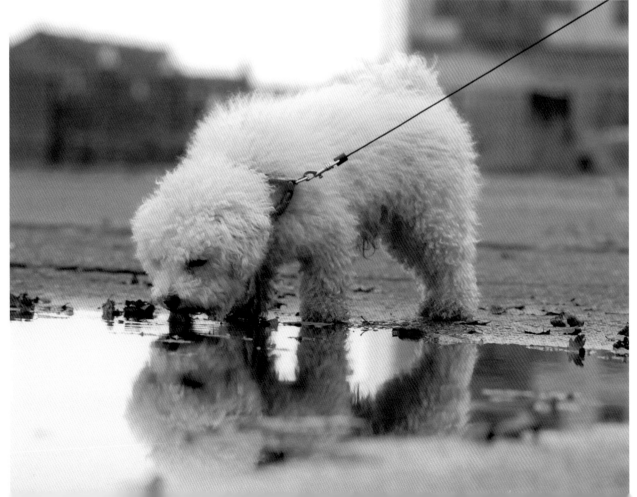

Guidelines for improved dog portraits

Unless shooting for a breed profile or show shot, there are no rules that need to be strictly adhered too when composing a portrait, a point worth emphasizing to clients who might be used to stuffy, traditional pet photography. There are some things you should always bear in mind though:

a. Ensure the eyes are clearly visible from stray hair and if possible contain catchlights. These sparking reflections will give the dog personality, and any portrait without them will lack the personality that it deserves.

b. If the legs are to be included in the image, consider their placement carefully. Is it stood in such as way as one leg conceals another, leaving it appearing to have only two or three limbs?

c. Observe the direction the dog is looking. If the dog is looking away from the camera, consider adjusting the framing of the shot to show context, or at least place more space in front of the eyes, which gives the illusion of context.

d. Does the portrait characterize the breed and is this a consideration? For example a Doberman, will typically cross its front two paws when it lies on the ground, a characteristic that aficionados will no doubt look for.

e. Shoot a series of images of a pet and observe the position of the tail and the ears. In some positions, such features will invariably look better than in others; a particularly clear example is when the animal's ears are pricked up, signifying that dog is alert to the sounds around it.

f. Always be aware of the potential distractions; both present already and those that may come along later.

g. Are you going to include any props in the portrait such as the dog's favorite toy? My experience suggests it is better to start with safe, simple portraits and only introduce props towards the end of your shooting session. If you bring these into play at too early a stage, you run the risk of overexciting a dog that has just been calmed down.

h. Spend time with the dog prior to picking up the camera. If the dog associates you with fun, or sees you as another playmate then you have a greater chance of securing the images that you want than if he sees you as a threat.

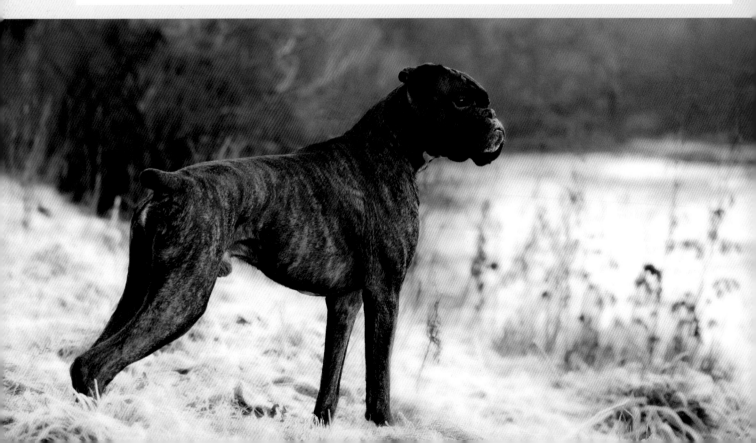

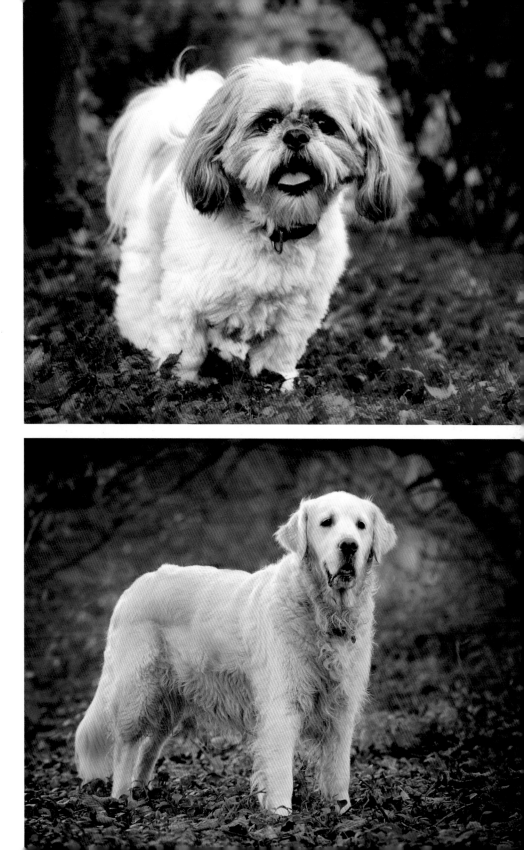

Opposite: The proud Boxer dog observes an attraction on the opposite side of river and provides enough time to capture this full length dog photograph. It should be noted that the intense white frost covering is significantly helping the dog stand out from the background.

Top: This autumnal dog portrait is clearly color rich as a result of the fallen red leaves. The overhead canopy of some of the branches also limits the impact of the "top" light.

Bottom: This Golden Retriever was photographed in a wood clearing at the side of a golf course. The woodland colors combined with the blonde coloration of the dog's coat again enables the dog to easily stand out from the background. Note that the camera angle to the dog has also resulted in all four legs being clearly visible, which is far more preferable to three legs being visible.

aking the photograph

When the moment arrives that the dog is standing or sitting as you intended, and the lighting and background is what you hoped (or settled) for, you may not have long to capture it. A split second, or perhaps a few seconds at the most will represent your whole window of opportunity in the majority of cases. It is therefore vital to make sure your exposure and other settings are ready in advance, as highlighted earlier.

Avoid scenarios where the whole family is dispersed around the dog

You can lengthen this moment by calling the dog's name, making silly noises, or even balancing a treat on the lens of the camera. Sounds, especially those with higher pitches, may well result in the dog's head turning and the ears pricking up. If you have your finger ready on the shutter and make the sound yourself, you can snap a reaction shot as the dog's eyes hunt for the source of the sound.

The handler may also assist by giving direction from a position directly behind your own. Try and avoid a scenario where a whole family is dispersed around the dog, watching and instructing at random. Beware, too, the perils of a Pavlovian response if too many treats surround the pet. Some dogs will salivate and focus on nothing except the tasty treats.

As always in photography, and especially in lower light environments, it's imperative to hold the camera steady. If I'm using a digital SLR whether stood, lying down, or on my knees, my arms and elbows are tucked in at my sides, providing a more rigid support base to my arms, both of which hold the camera, one on the body, one supporting the lens.

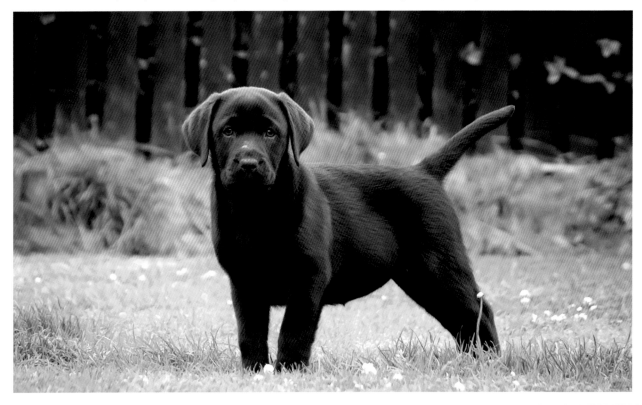

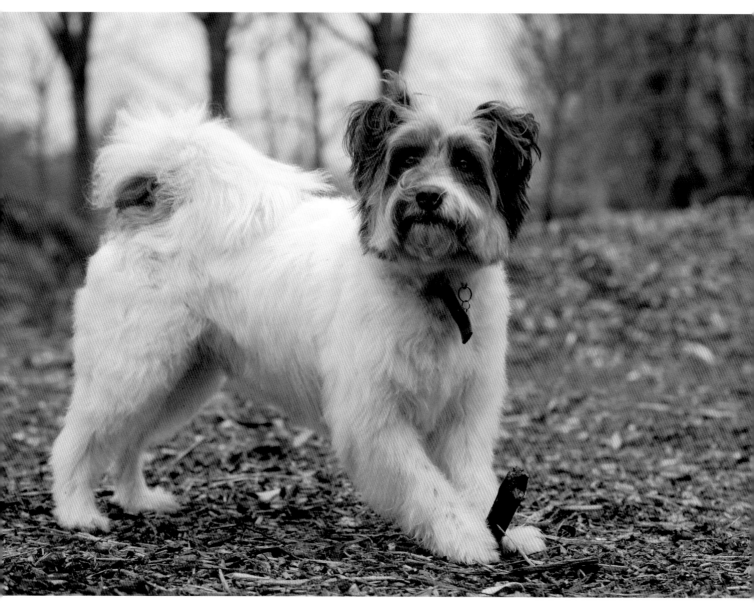

Opposite: This chocolate Labrador puppy compliments the scene, especially the brown colored fencing visible behind the dog. It would be better if the two back legs were more clearly visible, but before I could move my camera position the puppy was on the move again!

Above: The cloud filled sky helped tremendously in softening the harsh sunlight that would have directly hit this light colored rescue dog. The position of the front two paws grasping the stick indicates a playfulness in the dog. Wood chippings and distant trees provide the setting for this dog portrait.

Dogs in action

Photographing dogs in action at the beach, the open countryside, or elsewhere is extremely rewarding, as well as exhilarating, challenging, and exhausting. A dog, or pack of dogs in action does not necessarily translate to them running. They may be interacting with other dogs, engaged in the art of sniffing, jumping with joy, or playing. The list is endless, as are the photographic possibilities.

The great outdoors will present far more opportunities than the studio environment that is more commonly associated with static portraits. Many dogs thrive in the outdoors, with a myriad of scenes and smells to explore. The considerations for photographing dogs in action obviously relies on the dog having a basic level of obedience that at least extends to a recall command. Their obedience levels may be tested to the limits in certain environments, as the movement of squirrels, the chase of another dog, or the lure of a particular scent may prove too much of a temptation. There are also the welfare concerns highlighted previously, as well as keeping in mind the strategy you devised to be respectful of a dog's age and health characteristics. Such a route should also be respectful to the handler's general level of fitness and mobility since they themselves may come back to base looking more bedraggled and tired than the actual dog.

One approach to photographing dogs in any outdoor environment where the handler has not specifically requested a

Positioning themselves carefully, photographers can be primed and ready to capture running images

formal portrait is to initially conduct a series of observations. From such observations, and thinking creatively, you should then be able to derive your own strategy. For example, what is the typical separation distance from handler to dog? This will give you a clue as to the length of zoom of that may be needed. You will find that some dogs will stay glued to their handler's shadow and others will be more comfortable at great distances, providing the handler is always in the dog's line of sight.

The observation period may also reveal some of the dog's physiological strengths, like its muscle tone when running. Conversely, with some breeds of dog such as the Dogue de Bordeaux or Boxer, which exhibiting looser facial muscles, the act of running may exaggerate such features and the resulting photograph may be

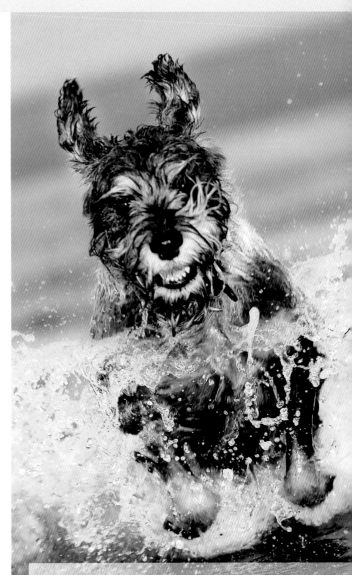

Millie, a Standard Schnauzer, running at full flight in an effort to catch up with its owner (and your author). To get this low angle in the shallow water I wore chest waders and kept the camera housed safely in waterproof protection equipment.

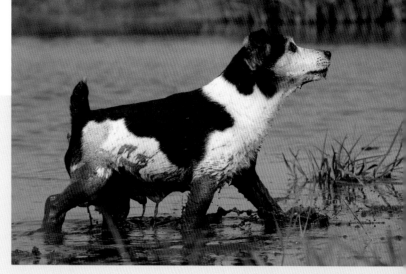

Right: The comical side of photographing on location, as the Jack Russell terrier runs out of legs and is inevitably going to end up in the bath after this photography session.

Below: This adult Boxer's timing is just amiss as it overruns the flight path of the flying disc. The head, eye, and mouth position clearly indicate the intended actions of the dog and makes the association with the disc.

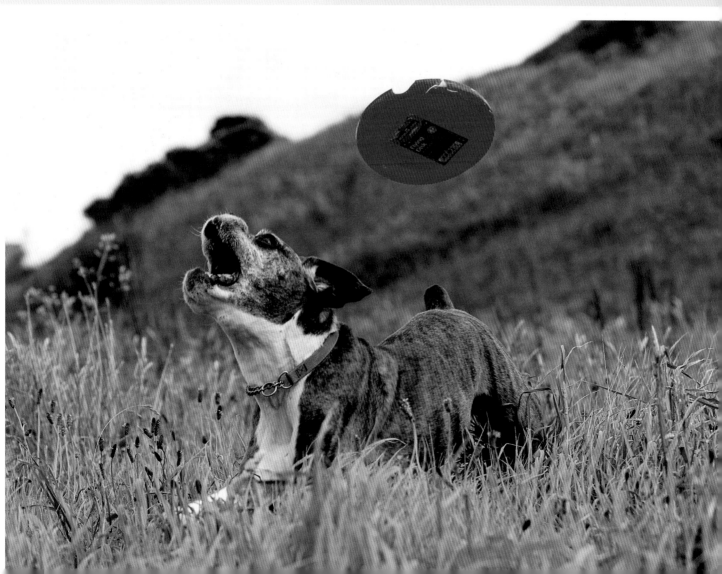

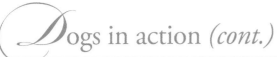

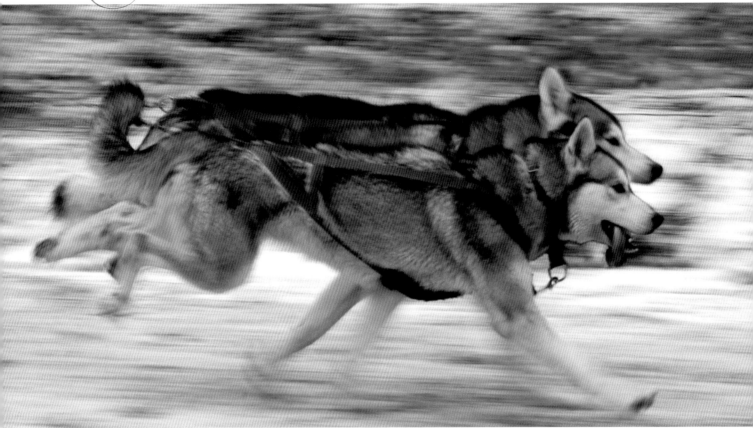

more of a quirky, comical shot. This may provide a great caption for a comedy pet greetings card, but may not please the client.

A Jack Russell Terrier may commonly have its nose close to the ground looking for opportunities to dig, or a working dog may well exhibit working characteristics, the obvious example being a Pointer dog's pointing stance. Images that characterize the breed of a dog are also likely to be viewed favorably, another reason for extending your knowledge of a particular breed and its traits during the pre-production homework.

In any one environment, the photographer must instruct the handler of the direction in which to walk. This could be to move away and then back to the camera position, across the path of the photographer, or in a semi-circle. In directing the handler's walking route consider the optimum lighting and background position for the dog. The responsive dog may stick like glue to the handler and follow their every move. Many dogs, however, will typically stop and sniff at a location and then bolt back to their handler at great

speed. By positioning yourself carefully you can be primed and ready to capture some running images. The running angle could also be dictated by collusion with the handler, who can throw a ball in a pre-planned direction in a game of fetch.

The breed type will generally dictate whether the dogs appear graceful and athletic, or clumsy and uncoordinated when they run. A Border Collie running, for example, will inevitably look more stylish than a Great Dane. Similarly, shooting overweight dogs running, especially from the side, will accentuate the excess baggage and will not look flattering. Once you have decided on your chosen shooting position and angle, ensure that your selected shutter speed is high enough to freeze the motion. You may wish to use the Shutter Speeds Table provided earlier in the book as an approximate guide. If your camera is capable of continuous focusing (often referred to as "continuous servo mode") then select it, as this mode will stay locked onto the target even as the distance between camera and dog changes.

Opposite: Two Siberian huskies racing in the early morning light. This image indicates the effect of using the "panning technique" and it is the camera moving with the direction of the dogs combined with the slow shutter speed of 1/80 sec in this image that has resulted in the blurry background.

Below left: The strong circling wind provides uplift to this Spaniel's ears and adds a degree of comedy to the owner's portfolio of images.

Below: A Weimaraner dog in action progressing through the long grass. Such environments clearly suit some dogs more than others.

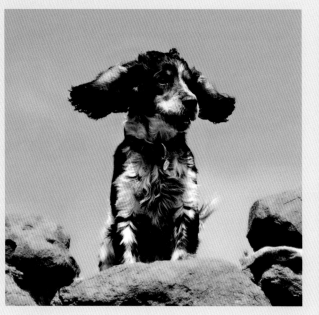

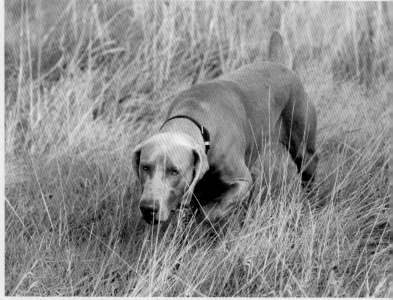

Where the light is too low to achieve the necessary shutter speed to "freeze" the dog in motion, the more advanced technique of panning can be employed

An SLR will also offer the ability to shoot continuously, at least until the memory buffer is full. That means you have the capability to take a continuous number of frames consecutively, at somewhere around 3 to 9 frames per second. By following the dog with the camera in servo focus mode and the shutter held down, you get a series of images from which you can pick the best. This is especially useful on those breeds of dog that run clumsily.

When you look through the images, check the legs. My preferred frame is typically the one that shows the front legs up or at full stretch, rather than grounded. On loose sand, water, or dry earth the action of the feet disturbing such elements can add drama.

In situations where the light is too low to achieve the necessary shutter speed to freeze the motion of a dog running, you can still try panning. A deliberately slower shutter speed is chosen, perhaps between 1/15 and 1/30 sec. The ISO and camera's aperture are selected carefully to give the correct exposure at these slower shutter speeds. The subject should be running across your field of view, keeping the same distance from you, and you should follow it with the lens, matching it's speed exactly so it stays in the same part of the viewfinder. Because the lens is moving as you shoot, the background will blur, but relative to the lens the dog stays in the same place, so is free of motion blur.

*P*redominantly white or black coats

Dogs that are all white in color, such as the Bichon Frise breed, or those that have a significant amount of white coloring to their appearance, present two unique problems to the photographer. The first is when shooting outdoors in bright sunshine where the sun is quite high in the sky, this top lighting can result in the detail of the fur at the top of the white head burning out.

The situation maybe overcome by an assistant holding a gobo in the path of the sun's rays and the dog's head. A gobo (literally "go between") is a filter that blocks the intensity of strong lighting, or in some cases even textures or patterns it. However, In pet photography

Top lighting can result in the detail of the fur at the top of a white head burning out

this option is not always practical; it may present an unwanted distraction for the dog. It may be easier to head for a shaded area, or an area such as a porch or canopy of trees that provide filtering of this top light.

The second problem when filling most of the frame with a predominantly white dog is that the dog may appear underexposed. The high reflectance value of the white coat may well trick the camera's metering system into believing the scene is too bright, which means it will underexpose the image by way of compensation. This can be overcome by increasing your exposure in manual mode by up to two stops, or by settings your camera's exposure compensation feature to a positive value, like +1 or +2. Don't go too far, however, as overexposed areas are harder to recover digitally.

When you are shooting a black dog the reverse scenario holds true, with the risk and you may well need negative exposure compensation settings (-1 or -2), to make the black detail of the dog appear black rather than gray in appearance.

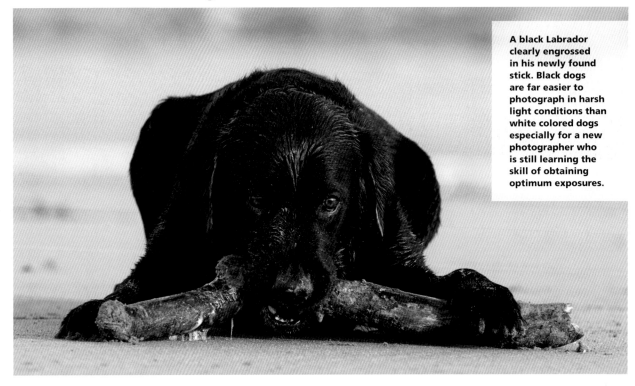

A black Labrador clearly engrossed in his newly found stick. Black dogs are far easier to photograph in harsh light conditions than white colored dogs especially for a new photographer who is still learning the skill of obtaining optimum exposures.

This image is dominated by both light and dark tones of roughly equal proportions. In this situation, with the even light of cloud cover, the exposure obtained from the camera's automatic exposure modes may give you a near perfect exposure.

Dog group portraits

Many handlers have more than one dog, and ideally would like all of them to be in the same image. Of course, the more dogs you attempt to photograph at the same time, the more challenging the photograph is, since each dog will have their own personality and quite possibly their own agenda to follow.

Photographing dogs of a similar breed, age, and upbringing will generally prove easier than a combination. Rescued dogs, for example, are not always comfortable around others. There will inevitably be one that finds it more difficult to fit in with your intentions. Another challenge of different dog types is that they will likely exhibit coats of different colors and textures, which will require some degree of compromise in choosing your optimum exposure. For combinations of white and black dogs it's generally

The composition may be based on dog breed, objects, props present, or the light

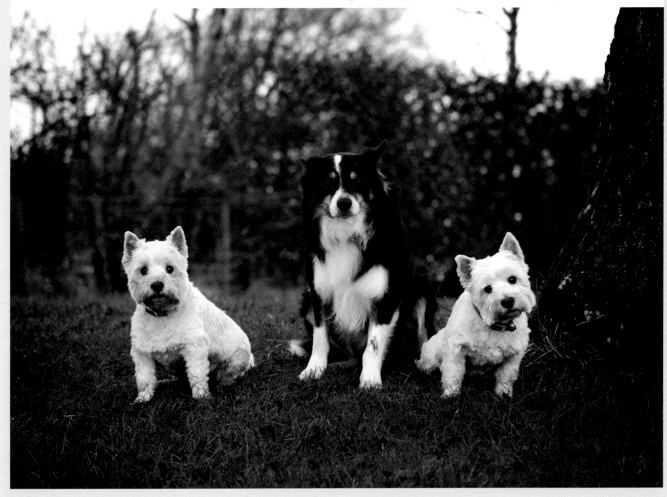

Opposite: The two West Highland White terriers at either side of the Border Collie give balance to the composition.

Below: A tree stump provides the scene for the two King Charles Spaniels to pose for the camera.

Below: A pack of three dogs belonging to one owner that are more than comfortable positioned close to each other in this dog group portrait.

Bottom: A quirky, comedy image showing the little boy "driving" the quad bike. Note the sleeping dog between the legs of the back dog.

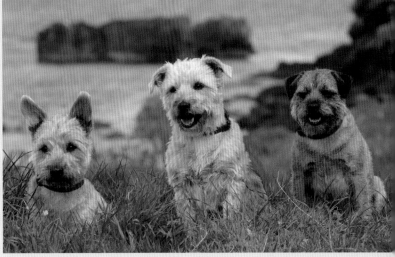

preferable to retain the detail in the white and lose some of the detail in the blacks, so expose for the lighter colored dogs. If the dogs are of the same breed or color markings then this aspect is obviously much easier.

When composing you will need to be led by the number of dogs in the same group. You may want to opt for a pyramid shape, with the taller dogs in the middle of the group and the smaller ones at the ends, but you will have to acquiesce to the dictates of the dogs' personalities. For example, if Buster and George are not that friendly with each other they will need to keep their minimum separation distance or instinct will take over.

The colorations of the dog's coats is a prompt when positioning them. For better symmetry, two darker colored dogs might be placed at either end of a group of three, with the lighter colored dog in the middle. The composition may be based on dog breed, objects, or props present or the strength and direction of the light source. For instance, it is advisable to put the darker colored dog nearer to the light source, helping to clarify details in its coat. There are no set rules, only considerations that need to be thought out in advance once you are familiar with the pack that you will be photographing.

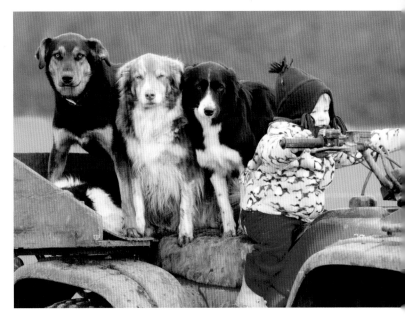

Dog group portrait tactics

When presented with a group of dogs the first thing you should do is try and spot which are the potential troublemakers and keep an order of obedience in mind. The most obedient dogs should be positioned before the selective hearing or self-ruling dogs. You'll also need a sufficient depth of field to keep the eyes and noses of each dog in focus since they often shuffle a few inches from their placement and this can be enough to have some of the dogs not quite as sharp as intended.

Make sure that the location is as free from distractions as possible. If you are working in the studio have the minimum number of people necessary to supervise the dogs. When outdoors, try to minimize the likelihood of other dogs wandering into your subjects view (or nasal range). You'll notice instantly if you've overlooked this because you'll have lost the attention of your subjects, all of whom are now staring elsewhere. This obviously doesn't happen in the studio environment.

Aside from avoiding distraction, your setting must also serve as a photographic set. Some potential locations will have natural or manmade features such as trees, mounds, gates, or walls that will help keep the group together. Such areas should be researched during the reconnaissance stage.

Food is probably best avoided for reasons mentioned earlier

Once you are ready to shoot the decisive moment is when all of the dogs are facing the camera. If one dog is looking elsewhere in the portrait, and the remaining dogs are looking at the camera, the image won't quite have the same impact and the client is likely to say (or think), "If only little 'George' was looking too!"

It's at these times that some tactics will come in handy. Food is probably best avoided for some of the reasons mentioned earlier in the book. Unless I have a pack of deaf dogs, I'd probably opt for making sounds. Another method is to carefully hold the camera, have a squeaker under your armpit, and squeeze the squeaker just before pressing the shutter. I've been known to throw my car keys in front of them, gain a successful shot, and then spend the next 10 minutes looking in the long grass. Be careful what you are throwing and certainly don't try that trick if there are any drains or watercourses directly behind you.

An old technique of some professional photographers is to position a group of dogs in a tight composition on a high table that has a blanket or sheet covering its topmost surface and front

face. Several assistants or handlers are positioned at the back of the table and low down and can discreetly hold the back of those dogs likely to escape from the scene. This is achieved by the handlers stretching their arms above their heads and holding the back ends of the dogs. It goes without saying that the success of the shot is dependent on the experience and familiarity of the handlers, each dog's temperament and the size of the dogs in question. A litter of puppies may be far easier to handle than four excitable Great Danes. If successfully executed, the handlers will not be seen in the image. If a hand is partially seen it may be possible to edit it out in post processing, especially if there is a background that can easily be cloned from.

When photographing groups of dogs, another useful tip is to keep your camera settings consistent, particularly the focal length of the lens if using a zoom, and ensure that your camera to subject distance remains constant. This is useful in a scenario where one dog will ultimately not comply with the request to gaze at the camera when all other participants are willing. It will then be typical that just when the obedient members turn their gaze away from the camera, the awkward member decides to give you their attention for a split second. By keeping your camera settings consistent and capturing this image it may be possible to clone in the head from this frame and onto the image where the majority of the dogs are looking attentive.

Opposite: The one seating, one lying position of these two Boxer dogs greatly aided the sought after "pyramid shape" for this composition. A good level of obedience was necessary to manipulate the dogs into such a position quickly.

Top: Three different breeds, three different heights, and varied temperaments dictated the positioning of these dogs and the order that each dog was brought into the group.

Right: This pack of hound dogs are far happier chasing than posing and it's easy to observe the clumsy composition in this photograph.

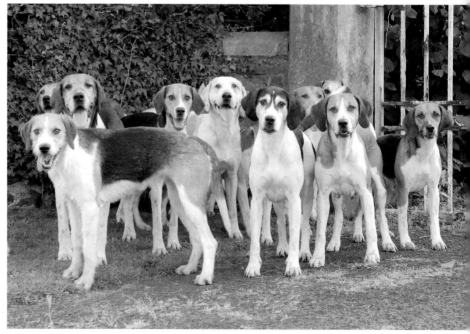

ittens

Kittens, like puppies, are full of life one minute only to be curled up in a ball and sleeping the next. While in a lively mood, they can certainly give the photographer the runaround. As a boy I used to have great fun teasing our pet kitten with the light from torches, circling the illumination on the carpet and watching the young kitten in pursuit of the light beam. If my father was changing the video cassette and kneeling down, his crouched position would sometimes cause his shirt to lift slightly at the back. This would be the perfect opportunity to flash that beam on the bare skin and within a split second the young kitten would be darting through the air before reaching its intended target, much to the displeasure of my father!

Those experiences in youth have helped shape my understanding of young kittens and their behavior. Kittens are some of the most curious and mischievous young pets you may come across. It's worth zipping or fastening your camera bag up on a kitten shoot since once of their favorite games is hiding and surprising you when you place your hands back in the bag. These tendencies can obviously be turned to your advantage. The handler may have lots of cat toys, items dangling on pieces of string, and other objects to keep the kittens entertained, but even if they don't, it is certainly worth building up your own bag of tricks in which to entice the curious kitten.

Kittens are some of the most curious and mischievous young pets you may come across.

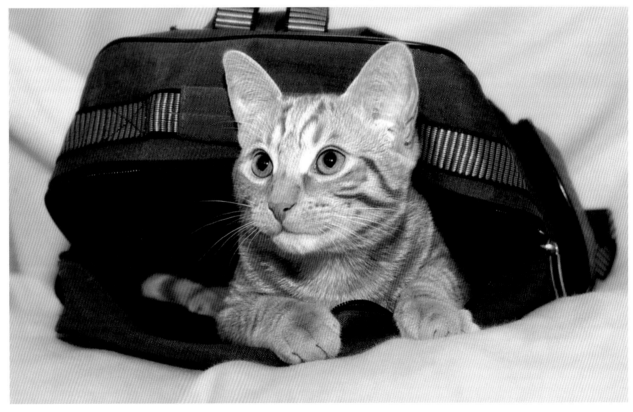

Kittens, in a similar manner to puppies, will explore the space given to them. One of the key differences is speed; they can be much faster when they decide to really move. They are capable of reaching a wider range of vantage points within any room's confines, too, such as upon tables, window ledges, and high book shelves.

Since they are such explorers, and significantly less dependent on the company of humans, you and the owner should assess which available rooms will be used prior commencing shooting. It's important that you have done your homework with respect to the existing light levels, both from window light and the handler's own household lights. Ask the handler where the kittens like to explore or play when they are not huddled in the litter keeping warm. If their sleeping quarters and play areas are both in the darker confines of the room, where perhaps the lighting is not the greatest, can the rest areas or play zones be tweaked? If the kittens like to rest on an old couch that has its back to the only window, could it be turned around or moved across to the other side of the room to allow more light onto the play area and their sleeping position?

Barring a few exceptional breeds, kittens and cats have much flatter faces than most dogs and the distance between eyes and tip of nose is much reduced. This reduces the depth of field necessary for at least keeping the eyes and nose in sharp focus, which greatly aids shooting in indoor environments. In such low light levels you may be shooting with the aperture wide open.

In other words, it is possible to set a maximum aperture (such as $f2.8$) in order to let the maximum amount of light through the lens, and a high ISO setting to obtain a faster shutter speed. You ideally need to obtain a high enough shutter speed to freeze the action without being able to use a tripod. A shallow depth of field will result in the cat's face being in focus and may also those distracting background elements such as the patterned wallpaper. For lenses with a smaller maximum aperture, such as $f3.5$ or $f4$, your indoor shot types may be restricted to using the brightest areas of the room, targeting resting cats, or introducing flash.

If your aim is for an indoor action photograph with the handler, perhaps holding or jiggling some of the available toys, your only option may be bounced flash photography or diffused flash. Luckily, the kitten's independence means that the effect of flash will have no impact on many kitten's agendas whatsoever. Others, however, may well react by hiding. Cellphone ringtones may also have the same effect, alienating the shy or more nervous kittens from the litter. The handler should be able to provide you with clues as to their temperament.

Opposite: "The kitten in the bag." Kittens and cats often love nothing better than a hiding hole in which to pounce out of, and my own equipment cases have provided them no end of opportunity.

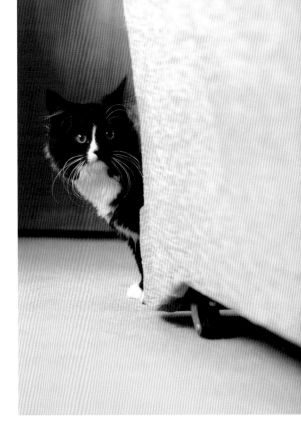

Top: This kitten was especially wary of strangers. The peering look around the sofa typifies its shy character. Fast focussing and exposure skills are necessary when a pet is constantly on the move.

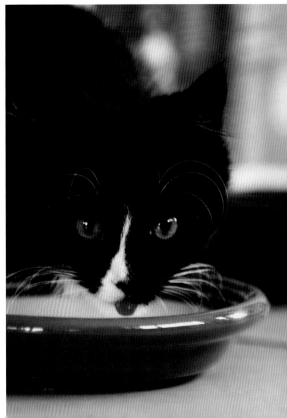

Bottom: The same shy kitten halts for a refreshing milk break, yet its instinctive nature means it is continually observing its surroundings for perceived danger.

Once you have the light controlled in any room, and the furnishing or objects placed appropriately, it can be beneficial to commence the photography aiming for portraits rather than action shots. Patience is needed and the initial aim is to have the kittens accept you and feel comfortable in your presence. Too much too soon and the shoot could potentially be a disaster, particularly if the kittens are on the skittish side.

As the session progresses, slowly introduce any toys or other objects that may prove fascinating for the kittens to explore. The use of the herb, "catnip" (Nepeta cataria) can also introduce some playful, comical moments. It can either be sprinkled or placed under loose fabric and should keep their interest for a while, allowing you to capture some quirky images. You can

The use of "catnip" can introduce some playful, comical moments

also introduce play sets slowly into a room such as boxes, tunnels, and other objects that the kittens can wander into and use as a hiding base. When awake, kittens—like older cats—love to have hiding places where they can keep an eye on you, yet are perhaps not that easily seen themselves.

Care should be taken in the construction of any such sets to ensure that there is adequate light in the areas they are likely to explore and also that beyond such areas the background is relatively uncluttered. Fabric or white sheets placed carefully over various objects may also assist with the light dispersion in any play set with the resulting light reflected favorably on the kittens. I've mentioned that cellphone ringtones have an appealing or repelling effect in respect of a kitten's interest, so it may be advisable to have any such phone on silent for at first, before resorting to playing with the ringtones if needs be.

This page: A young kitten grapples with a furry toy, with one paw holding the toy and the other poised to swipe the next thing that enters its range. Encourage such games near the better quality lighting within a room and choose complimentary backgrounds that will improve the photograph, rather than distract from the main subject.

Opposite, top left: A cover for the radiator, combined with the warmth, persuaded the cat to stay in position for this full length portrait image.

Opposite, far right: The kitten owner directs the play with a yellow string toy. An uncluttered background keeps the eyes clearly on the action of the kitten.

Opposite, bottom left: The menacing gaze of this kitten and the upturned tail end suggest it could be ready to pounce.

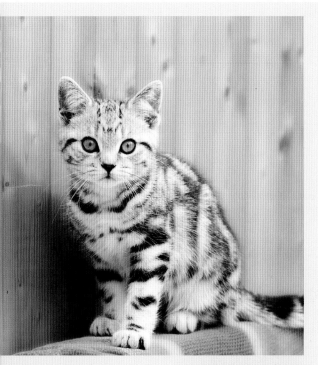
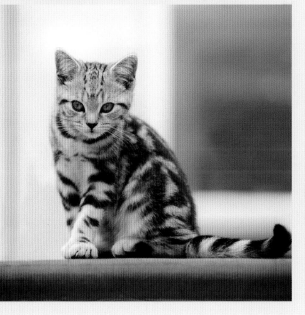
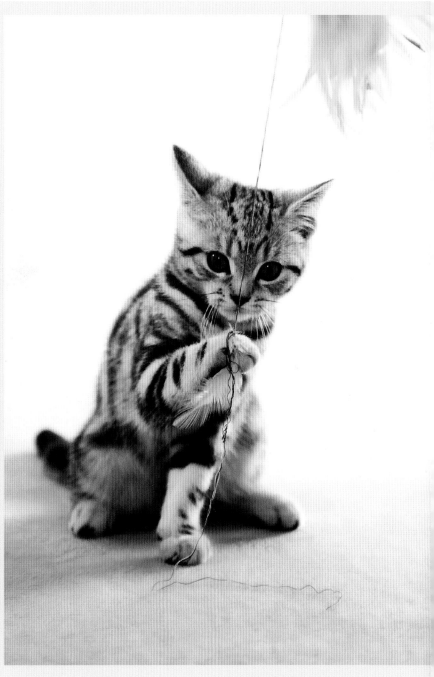

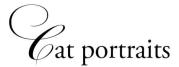

Cat portraits

The older, more mature cat may still be cajoled into a cat game similar to those that tempt kittens. They may, however, be less skittish, having seen a wealth of different faces, noises, and comings and goings in their lifetime.

There are some fascinating and varied pedigree breeds of cat in addition to the "Heinz," or typical street cat. Some breeds are inevitably more relaxed than others, and make taking pet portraits that much easier; the Persian is a good example. Other more

Some breeds are inevitably lazier than others and make taking pet portraits that much easier

athletic-minded felines may spend a good proportion of the time outdoors looking for the next mouse to bring back to the doorstep of its owner.

A cat that is nearing a sleep phase or has just awoken may present a great opportunity for a cat portrait since it will be far less energetic and may well stay still in a lying or sitting position. In examining the cat for its portrait, you need to recall any special characteristics of the breed that came up in your research, or other elements that the owner is particularly fond of. This could be a marking on the cat's coat, the color of the cat's eyes, or its gaze.

It is always important that these characteristics are recorded accurately in your photographs since the owner will be extremely familiar with such elements and have a far more critical eye as to whether they are accurately represented.

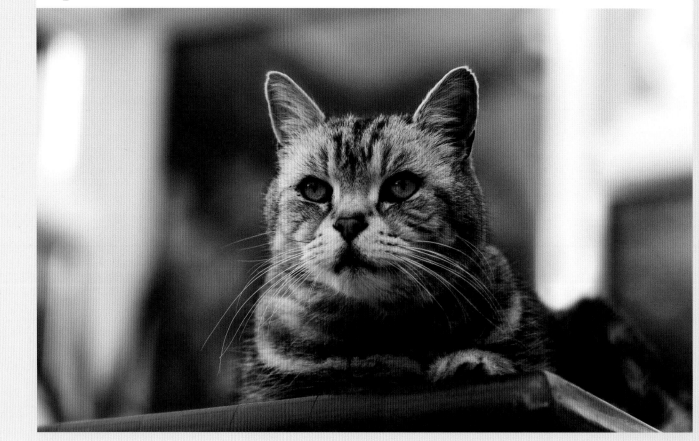

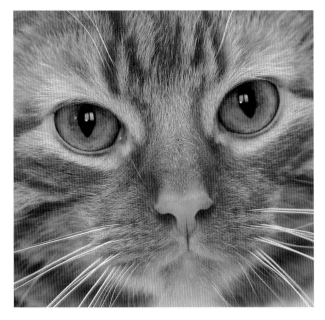

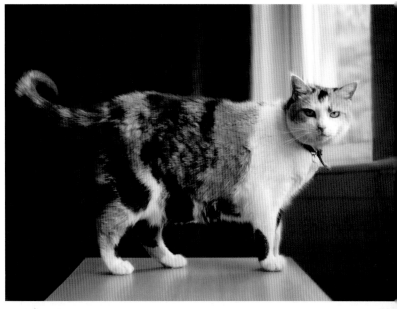

Above: In addition to full length, or head and shoulder images, experiment and zoom further for close crop images such as in this cat's face. Here 1/60 sec was fast enough at ƒ4.0, with ISO 200 set.

Top right: Cassie the tortoiseshell cat is most comfortable when the camera is at some distance. The leg position, stare, and swishing tail action suggest that this cat is not going to stay in this position for very long. Camera settings: ƒ2.8, 1/160 sec, ISO 400 were used after a third of a stop exposure compensation was used to overcome the camera exposing for the window.

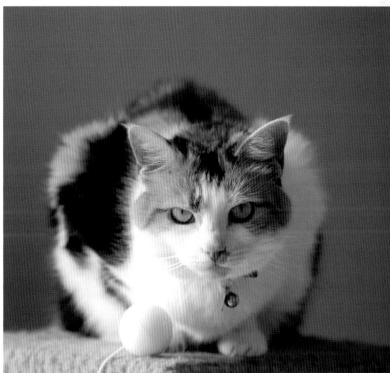

Opposite: This old cat lies on the table and observes the world outside the conservatory. The shooting angle has avoided the white window frame behind the cat's position "appearing" out of the top of its head.

Bottom right: A somewhat more tired Cassie provides a better opportunity for a portrait as she rests on her favorite rug. Captured at ƒ3.2, 1/160 sec.

Taking cat portraits indoors has one great advantage compared to the outdoor cat portrait: the environment is limited and there is no danger of the cat disappearing halfway through the shoot. As with kittens, the room should be examined for its necessary strengths and weaknesses in terms of light, furnishings, and objects. If the adult cat is more amenable to being moved by the owner to the preferred placement spot then it is important that the photographer has conducted all his necessary test shots in respect of exposure in advance and is at the ready.

For cats with more of an attitude, that do not like being handled, it be necessary to bribe the animal. Cats, particularly the smooth haired variety, will usually head for the warmer areas of a room and naturally find the most comfortable place to observe the everyday happenings in a home. Using tactics such as turning some radiators off and others on may aid you in getting the cat in the right area. A more precise alternative is to disguise a hot water bottle under some extremely soft furnishing, and give the heat some time to transmit to the upper, outermost layers.

Adult cats are more amenable to being moved to the preferred spot, but bribing still helps

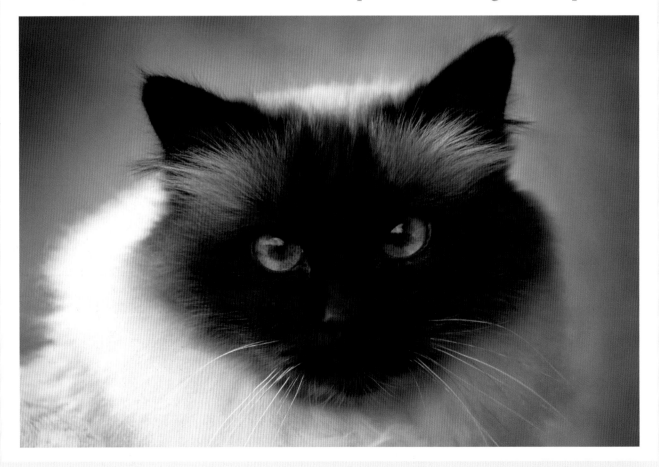

Opposite: A Ragdoll portrait image. This cat was stalking garden birds on the pavement, yet a silly noise was enough to distract it for a second and capture this look. This picture was captured at f2.8, 1/800 sec, and 400 ISO.

Right: The simple background and stage for the cat is provided by a table chair. Taking a series of successive shots will usually provide you with a few different tail position options. In this image the tail directly behind the cat was the preferred position. This picture was captured at f2.5, 1/640 sec, and 400 ISO.

Below: A relaxed Persian cat, a breed renowned for their ability to sleep, peers upwards from the kitchen floor. This high angle image would not have worked had the cat not been looking upwards. Caught here at f1.4, 1/200 sec and ISO 400.

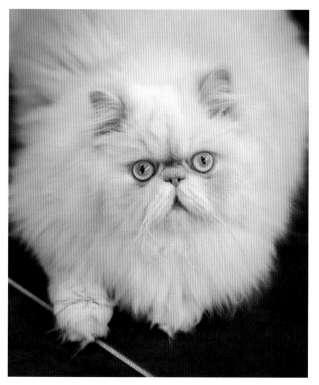

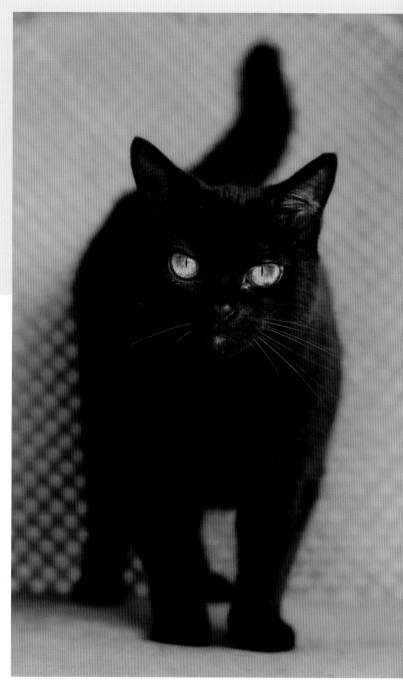

ats in action

Aside from cajoling kittens and cats into playing games, outdoor cats hunting, stalking, and jumping can make great images. You certainly need an element of luck outside, since a cat with the freedom to roam will not wait for the photographer to assume his or her shooting position.

The owner may be able to assist if a cat has a tendency to stay within the boundaries of the home, by selectively positioning the cat in requested locations. Cats will often assume high vantage points such as the top of a shed or other sun traps where they can gain a better pouncing position or experience the warmth of the sun's rays. Although this won't always help with your own vantage point, it'll certainly ensure good lighting.

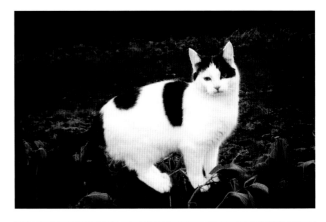

For me, the most appealing cat action shots are those displaying its natural stalking instincts

If a cat has a tendency to wander off, the use of a favored food treat such as shrimp may entice the cat to stay in a particular spot until the desired shots have been captured. Squashing aluminium foil to create shiny balls can also be useful for creating exciting objects that may entice the cat into leaping across a lawn. For me, the most appealing cat action shots are those displaying the natural hunting and stalking instincts. This could be of a cat eyeing up a bird in a tree or a trying to capture a butterfly on its flight path from flower to flower.

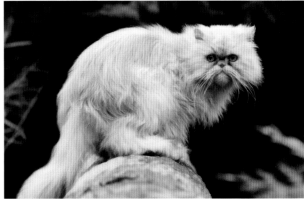

Top: This cat's search for mice was briefly halted by a brief whistling noise. Although the white markings of the cat are pronounced in the image, those darker markings are somewhat blending in to the background scene. This was originally captured at *f*5.6, 1/100 sec and ISO 400.

Bottom: Two chairs facing each other provided the stage for this cat image. The image was turned into a near-sepia tone in Photoshop.

Middle: It was necessary to climb a wall to shoot this Persian cat. Three seconds later and he'd made his next jump into the neighbor's garden, but fortunately the shot was stored on the memory card by that point. *f*2.8, 1/100 sec, and ISO 800 were needed in what was relatively low light for an outdoor shot.

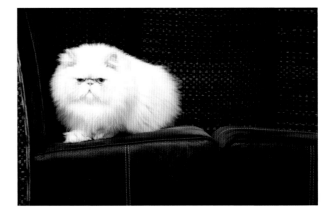

This image was achieved by leaning out of a window and making a suitable noise that tempted the cat to peer through an adjoining window to see what all the fuss was about. Aperture was *f*2.8.

at groups

Groups of cats can be the most challenging of all, depending again on the numbers, temperaments, and personalities. Your key challenge is keeping the cats together, after which you must gain their attention. Unless a group of cats is particularly sleepy it will need the owner's intervention to keep them together.

Using a warming aid for the selected area may prove beneficial. The owner's role is keeping the cats as relaxed as possible, perhaps by gently stroking the more troublesome cat of the group. The composition of the group and each individual's body position may also need to be tweaked by the owner under the instruction of the photographer. Again, if the cats are relaxed they may be far more responsive to the task.

The attention of the cats, and hence a look at camera, may be achieved by a subtle sound or by the assistance of a third person directly behind the photographer who is able to cajole the cats into looking in the direction of the camera, either by making one of their own sounds or by the introduction of a cat toy. The moment may be brief before the party scatters, so exposure must be correctly assessed in advance. An informal group of cats can also make a very appealing image, particularly if they are all engaged in different actions (cleaning, stretching, sleeping, and so on). After all, that's how cats behave when left to their own devices.

> Unless a group of cats is particularly sleepy, it will need owner intervention to keep them together

Below: "Synchronized paw movements." These two kittens were playfully observing their own paws during one game-filled session.

These two ginger cats were initially positioned on the couch that had an old black rug placed upon it, providing both comfort and warmth for the cats and maximizing the potential shooting time. ƒ16 gives good depth of field for sharpness.

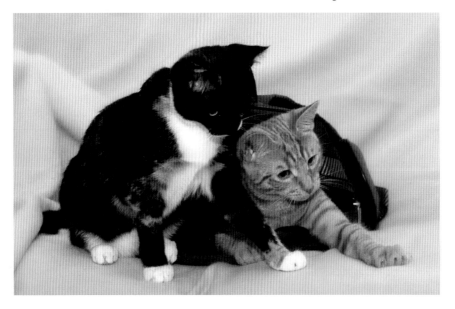

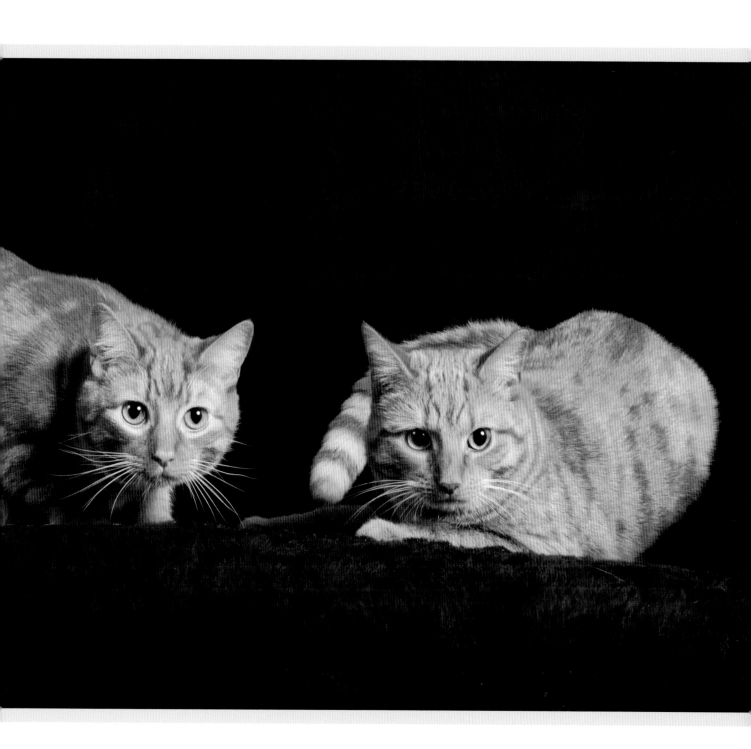

mall furry pets

Small furry pets are often chosen by adults for their younger children as a more practical alternative than a dog or cat. In the winter months an indoor environment is expected, but some animals will invariably be designated an area of the home, perhaps only venturing outdoors to their second enclosure on warm, sunny days.

The best shooting position is usually lying flat on the ground

Rabbits and guinea pigs, when given the freedom to move within a room, are generally easier than dogs and cats to photograph since any period of movement will usually be followed by the pet staying in the same position while it observes its surroundings and ponders its next move.

The best shooting position is usually to lie flat on the ground, framing the pet so it occupies enough of the viewfinder to have real impact in the final image. With the right lens you can frame the shot even more tightly, concentrating perhaps on the facial features. This is a great way to convey personality.

Given your likely position, rooms that have small tables and other potential hiding places must be accounted for in the preparation of the space. Smaller furry pets may head directly for such areas for reassurance, since similar hiding places in the wild would provide them partial protection. The light and exposure

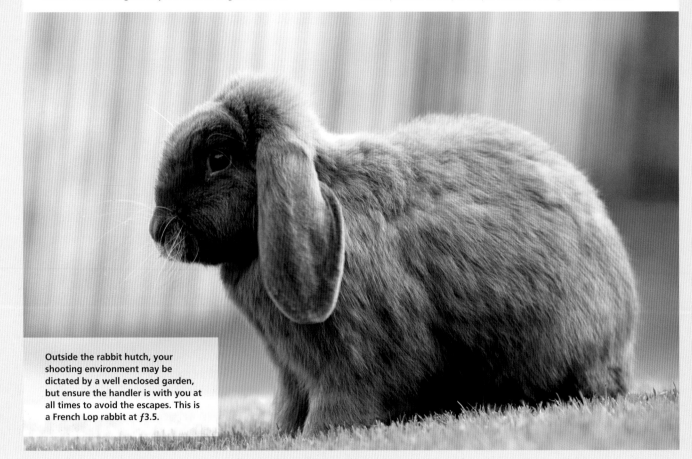

Outside the rabbit hutch, your shooting environment may be dictated by a well enclosed garden, but ensure the handler is with you at all times to avoid the escapes. This is a French Lop rabbit at ƒ3.5.

need to be assessed in these areas and, providing it is acceptable, the included furniture in the frame may even provide a welcome addition to the image's composition.

For even smaller furry pets, like hamsters and gerbils, creatures that are typically confined to a cage, it might be necessary to construct a set, either from natural materials including leaves, twigs, branches, and the like. A simple alternative may be to use an old piece of fabric or manmade material to create a colorful complimentary background, with or without small props. Introducing small pieces of food into such areas may provide you with the necessary time to capture the intended shots.

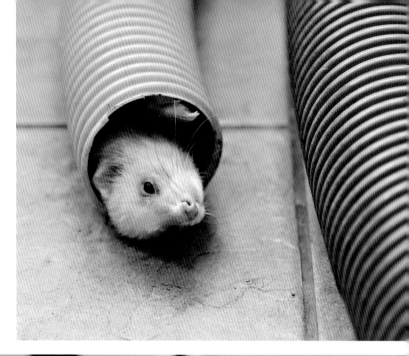

Right: Some old plastic tubing provided the perfect prop for this ferret to entertain himself as he repeatedly explored the length of pipe, sometimes, as in this shot, appearing out of the other end upside down.

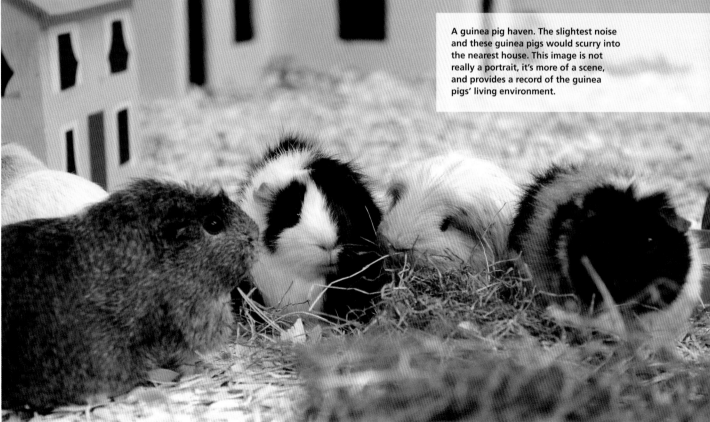

A guinea pig haven. The slightest noise and these guinea pigs would scurry into the nearest house. This image is not really a portrait, it's more of a scene, and provides a record of the guinea pigs' living environment.

*H*orses and ponies

Horses and ponies represent perhaps some of the largest animals that may be classified as a pet. Their natural environment is certainly not in the house and, when released from their stables, they are likely to be resident in a field. Depending on their usual environment it could well be advantageous to transport horses to more scenic locations such as a beach or country track.

Photographing horses is something of a specialist subject, but many of the principles seen elsewhere in this book can be applied. As before, you need to understand in advance the results the client is hoping for; a portrait, breed profile, or freestyle shot? There are two possibilities when it comes to including the owner too, they may stand with the animal or be part of a horse and rider shot.

You'll need to balance the owners hopes against the lighting and background combination available, since—given the size of the animal—it will usually be impossible to construct your own sets. Examine the view 360 degrees around the chosen subject for potential distractions and complimentary tones and colors and devise a strategy to accomplish the requested images, including choosing the best position for yourself and your subject.

Ensure that the horses are well groomed before your arrival, and decide in advance the appropriate people to assist with the handling or direction of the animals. It can be especially useful to have a third person who can assist with the direction of a horse, especially if the second is to be sat upon the beast. The third person can still provide the necessary stimuli in which to entice any horse or pony to lift its head and look in the intended direction. The second and third person should also be aware of the preferred standing position you're research has taught you to aiming for. This stance may well be matched to specific breed, so check your reference material.

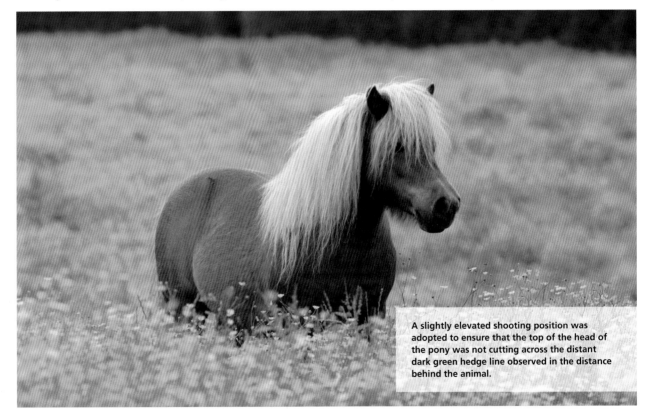

A slightly elevated shooting position was adopted to ensure that the top of the head of the pony was not cutting across the distant dark green hedge line observed in the distance behind the animal.

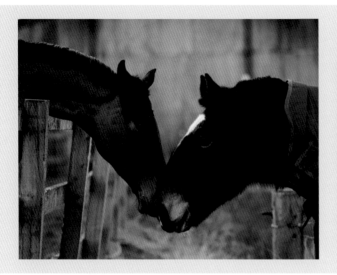

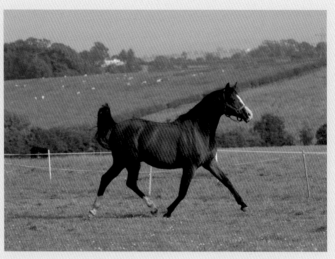

Horses, particularly stallions, are extremely large animals and you need to be confident with them, especially if entering an arena or shooting at a stallion grading event where your remit may be to photograph many horses over the course of a day. Always be aware of your own safety and that of any pony or horse. It is sometimes recommended to give such an animal a food treat prior to conducting photography to signify to the horse that you are a friend and not a foe. Furthermore, flash is not recommended since any horse or pony should not be startled and, depending on the circumstances, is always potentially dangerous.

Always be aware of your own safety and that of the horse

If photographing any horse and rider, ask the rider or owner in advance of picking up the camera what type of images that they are seeking. For instance, it may be a jumping image or galloping image. If you are inexperienced with taking images where the body posture, position, legs, and head may be critically examined, ask the owner to show you some examples of similar images and ask them to explain why certain images are so appealing. You can rapidly learn a lot about the specific elements of a horse's profile or position from the owner's enthusiasm in this way. If it is your first time photographing horses do not be afraid to experiment with the camera, photographing both close up head shots and full length shots. The owner may alternatively be seeking general horse interaction shots and may not be quite as critical over the finer elements.

Above left: The greeting of two horses in adjoining fields. Such images cannot be orchestrated, and rely on patience and the predictive positioning of the photographer. Settings were ƒ4, 1/500 sec, and ISO 400.

Below: Owner and horse interaction image. Nobody should know the horse better than its handler who devotes most time to it.

Above right: A galloping horse. Take a series of consecutive frames and observe the preferred leg and body positions for the most desirable image. A high 1/1500 sec shutter speed is balanced by using ƒ5.6 and ISO 400.

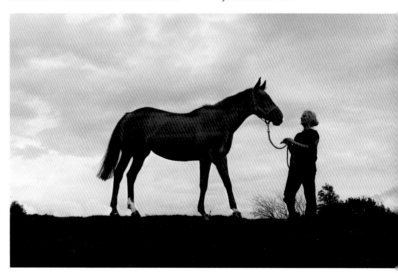

irds of a feather

In photographing pet birds we are typically going to encounter budgerigars, parrots, or cockatiels that have lived their lives in captivity. Birds can be extremely sensitive and their welfare must be of paramount importance. I would personally never use any form of flash photography unless as a last resort, and only if the owner had specifically informed me that such a pet bird was used to flash photography.

Perhaps the biggest potential problem, however, is the cage or enclosure in which the bird typically spends a good proportion of their time. These often comprise of thin wire bars on to which various less-than-photogenic attachments are fitted, such as a food container, mirror, or water vessel. Any such cage may also be tucked away in a corner of a room where the lighting is perhaps not the greatest.

So what are the potential strategies for photographing our feathered friends? Firstly, if a bird is confined to a cage, one technique is to take up a position near to the cage, providing of course that the bird is still comfortable with your distance ,and then shoot with the widest aperture setting available to you. The ƒ1.4 to ƒ2.8 territory, if

your lens allows, is ideal. By focusing just under the position of the bird's eyes, at the middle to back end of the beak, you may have just enough depth of field to retain the sharpness on both the eyes and the beak yet blur those metals bars to the extent that they might not even be noticeable. If the depth of field is now too shallow to maintain, you can either opt to shoot the bird more in profile, or try moving the camera position back slightly, which will increase the depth of field at any given aperture.

Birds are basically either perched or flying. Indoors they will be predominantly perched, and so relatively still. This makes it one of the rare situations in pet photography where you can consider using a tripod, potentially the only solution if your lens has a relatively narrow aperture. You can also seek to move the perch into an area that is better illuminated. You should also considering draping or fixing some colored or darkened material in the background of the expected bird position. I do not mean affixing such material to the cage and risk blocking light, but rather affixing it to a wall or other nearby objects to give a complimentary background color to the plumage of the subject itself.

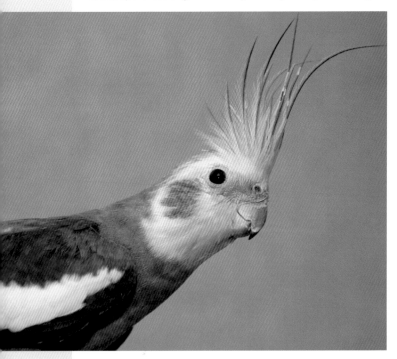

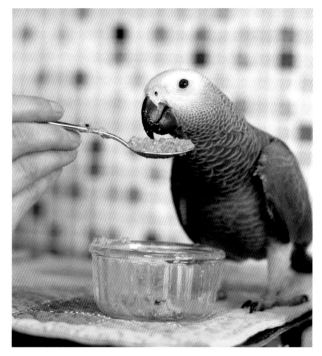

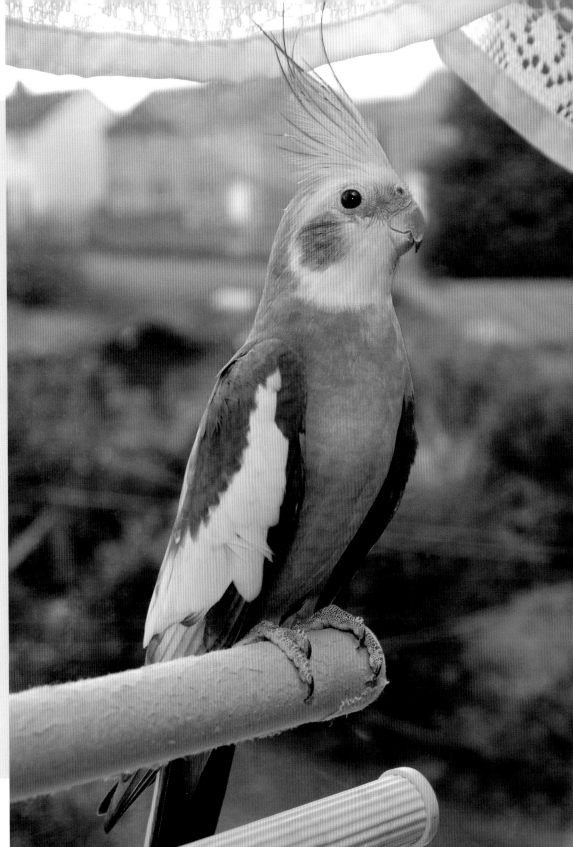

Far Left: A cockatiel positioned against a different colored background helps isolate the bird and puts greater prominence on the subject, here captured at ƒ4.

Left: Feeding time for an African Grey Parrot. This record shot of the parrot's daily activity provides a great memory for the owner of the parrot's habits and characteristics. The narrow depth of field was achieved using an aperture of ƒ2.

Right: A cockatiel perches on its familiar ledge with the distant houses of the neighborhood providing a sense of familiarity. ƒ6.7 is enough to keep them from appearing too sharp,

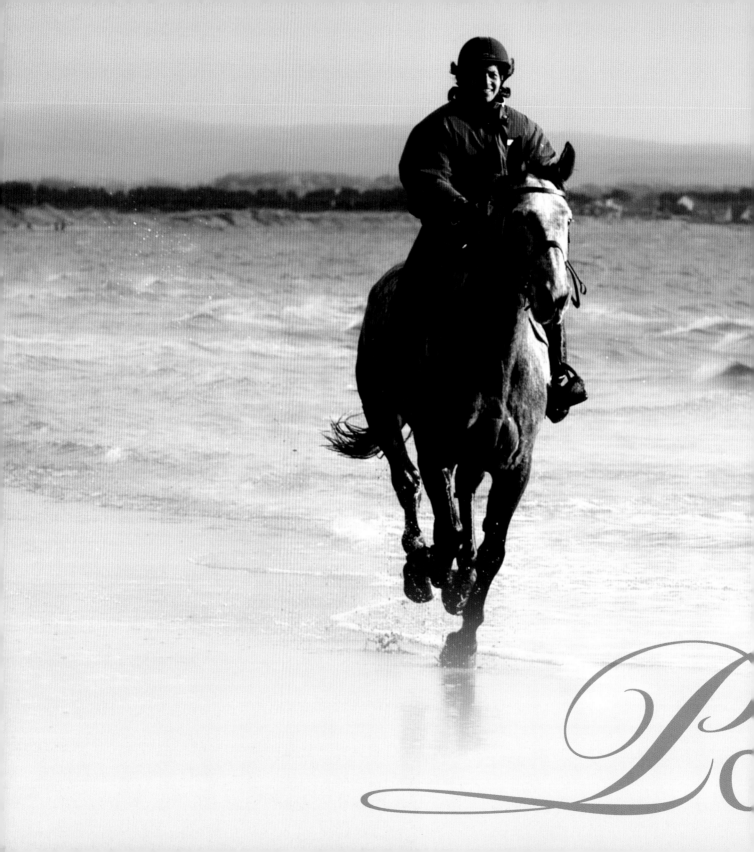

In the main, this chapter in the main assumes that you are returning from your pet assignment with the images still on the memory card. The next stages are almost as crucial as the initial preparation stages and taking the images themselves. It covers the crucial stages of backing up your digital data, post-production, and, most importantly, displaying your images whether they are in a physical form such as a framed print or being shared among friends digitally via the web or some other digital media.

st production

igital output

This section of the book is all about possibilities, since that is what post-production offers. Your objective at the time of taking a photograph should always be to minimize post production work and get it right "in camera" rather than rely on your image editing software to fix poor exposures, color, or composition. Rather than seeing software as a tool to fix them, though it can certainly lend a hand, look at it as a way of doing more than you could with film.

Many of the compact cameras and general prosumer cameras may well sharpen an image and boost the saturation and contrast at the time of shooting. It is worth noting that this will not automatically happen with professional digital SLR cameras. Many digital cameras do give the option of adjusting various values via their menu systems such as sharpness and noise reduction and so on. It's recommended to set such options to their lowest settings

Adobe Photoshop is an extremely powerful image editing application but can appear daunting at first

if you intend to take greater control of such parameters in your editing software, since your camera and the software will be trying to do to conflicting jobs.

If time is more limited you can use the camera's processing tools. Controlling these options in image editing software, however, gives you the advantage that you can fine-tune and make precise adjustments with the benefit of a clear screen, rather than relying on the camera to guess the intended adjustments.

Top right: A screen shot from Adobe Lightroom, a powerful image management application that can be used for cataloging images, making simple edits, and managing your library of pet photographs. Lightroom can also display slideshows of your images and export to the internet, making it something of a one-stop digital darkroom. Adobe also keep it regularly updated so it can take advantage of Raw data from all major camera models.

Opposite: A screen shot of Adobe Photoshop showing a dog image in progress. The program has a multitude of menus and options, but you are only ever likely to use a small fraction of the available tools with respect to your image editing and post processing. If you have a limited budget you might prefer Photoshop Elements, a more modestly priced version which dispenses with some of the less essential features.

Bottom right: An unsightly electrical cable is being removed using Adobe Photoshop's Clone Stamp tool to reduce clutter in this picture.

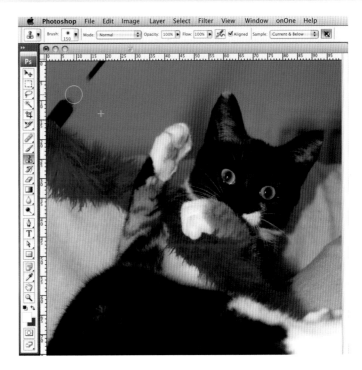

However you approach the computer, it is important that you have a suitable work flow that is consistent and repeatable for managing your images. For example, if you intend to adjust the sharpness, contrast, color, and file type of each image, ensure that you become accustomed to the same routine each time you work. For example, connect the camera, copy the files, convert all the files to TIFF, open the images in order to crop, make exposure corrections, color correction, contrast, sharpness, then finally save as a JPEG.

Since the processes is partially mechanical, you can save time by "batch processing," applying a particular image enhancement step to a multitude of images selected. Photoshop tucks a useful file conversion tool in it *Files > Scripts > Image Processor* menu which can convert the file type of a whole folder of images at once. If you often repeat the same changes to an image, such as a black-and-white conversion, you might find that it is worth recording it as an Action. These are repeatable sequences of steps that can also be applied to a batch of images.

Adobe Photoshop is an extremely powerful image editing application, but to accomplish many enhancements to your images you need only become accustomed to a small fraction of the available tools. There is a multitude of different ways to work in Photoshop, of which only the most pertinent to pet photography can be fitted within these pages.

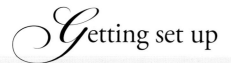

Getting set up

Before you can use your computer to best effect, you should start by ensuring everything is working as best it can. Perhaps the biggest single thing you can do in this regard is to calibrate your monitor.

That's because the monitor is the most visible part of a sophisticated color management system that your computer employs to ensure, very simply, that the red your camera sees is the same one the monitor displays and the printer reproduces. That might sound a relatively trivial process—doesn't the computer simply assign certain colors certain values?

The short answer is yes, it does, but each device attached to the computer—the monitor, the printer, and so on—tends to add its own influence to it. If the computer assumes it's value is pure, it can compensate for the variance of each of the other devices by assigning each a "color profile," through which it will pass (and alter) any color values that it passes to the device.

The images you see and manipulate on your computer need to have the same appearance when printed

So essentially, color profiling "filters" the data to ensure you always see the correct color, but it only works if all the filters are correct. That's where profiling tools come in. A relatively inexpensive device known as a colorimeter is connected to your computer, usually by USB, and placed against your monitor screen. Some supplied software shows a sequence of colors to the colorimeter, and takes readings from the device, and uses the data to produce a color profile for the display.

Similar technology is available for printers, and while manufacturers install preset color profiles in the printer drivers, a more accurate result can be achieved using external measurements. These devices require you to make a test print and then measure the colors from the squares in that page. You will need to make a profile for each different kind of paper that you use.

Of course, all this hard work is worthless if you have not set your computer up in an environment where the light is relatively neutral. The colors displayed on your monitor may appear different to the naked eye at different times of the day depending on a number of factors; such as whether the computer monitor has warmed up, the variability of your own eyes, and the ambient light. Cathode Ray Tube (CRT) monitors and modern flatscreen LCD monitors,

once calibrated, do not remain so indefinitely. Calibration should be conducted every few months on an LCD, and few weeks on a CRT, more frequently as their age increases. That is why it's better to own a calibration tool.

Once your computer is in place, and you have followed the on-screen calibration instructions, you simply need to make sure that the newly created profile is being used in your system's Color Management, usually in the system settings.

Left: Spyder 3 colorometer is a popular choice among photographers, reasonably priced with easy-to-use software.

Bottom: Checking the colors produced by an inkjet printer using a printed test sheet.

Opposite: The colors and brightness of this horse have been given a minor boost in Adobe Photoshop.

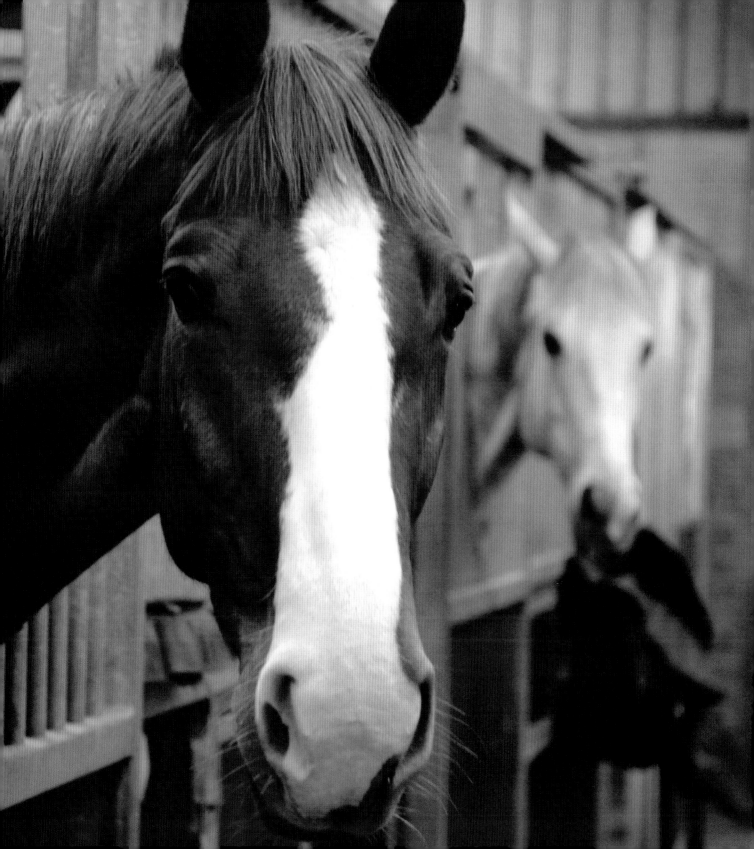

Workflow

Expanding on my comments about digital working at the beginning of the chapter, I'll take this opportunity to follow an image from the moment it's moved onto the computer. As I do so I'll be explaining why I work in this order, giving you the opportunity to compare it against your own workflow.

STEP 1 BACK UP THE WHOLE SHOOT

The first step after returning from a shoot is to transfer the images to a named folder on your computer and then immediately make a second back up to either an external hard drive or preferably a writable DVD or CD disc. I cannot stress enough the horror (and permanence) of losing valuable or sentimental images from sheer complacency.

STEP 2 IMAGE SELECTION

You need to selectively choose the images that you wish to process further. This can be done in the software supplied with your camera, or in browser software like Adobe Bridge or Breeze Browser. They will allow you to tag or code an image with flags or a star rating as you progress through the image previews. Don't delete images, since they may yet prove useful at the editing stage (to clone material from) or in the future when improved post processing skills allow you to see new potential in them.

What images will make the short list? My criteria for selection is to firstly eliminate any images that are technically poor, out of focus, or perhaps those images made while undergoing any exposure tests. I then critically examine each remaining shot in turn and identify which images are worthy of editing on the grounds that they have appeal. I'm looking for a technically sound, well composed portrait, a quirky comical portrait, a moody portrait, or some other x-factor. With running shots, I will be looking at the body, leg, and head position to determine if all three elements are appealing. Finally, compare any similar images remaining for minor differences and retain the favorite.

STEP 3 CONVERSION TO TIFF

The TIFF image format is a good file format since it is used professionally, can be read on Macs or PCs, is a non-lossy format. Photoshop can even include its layer information into the files so, when open in Photoshop, changes can be revisited.

STEP 4 EXPOSURE CORRECTION

Although I would expect my exposures to be fairly accurate at the time of capture, sometimes by using the histogram data and associated sliders it is possible to make refinements or even sacrifice image detail in certain areas to improve an image's appearance by adding contrast. This may be useful if you are intending to convert an image to black-and-white at some stage. It is always a good idea to make any image enhancements or manipulations using separate layers so the original image is preserved.

STEP 5 IMAGE CROPPING

Following any adjustments to the exposure, the image is usually cropped to a specific aspect ratio such as 10 × 8 inches or 12 × 8 inches. Sometimes a square crop is an option depending on the picture and your ultimate plans for its display. If any element of an image is perhaps detracting from the overall quality of a picture such as a distant, shining reflective object, cropping is one method of eliminating it, though that depends on where the distraction is relative to the subject. Cropping may also allow your pet to be repositioned for prominence using the classic Rule of Thirds, though bear in mind that as you crop you lose resolution.

STEP 6 COLOR CORRECTION

Using an adjustment layer, the color hues and tones may also be manipulated for effect. For instance, when shooting in JPEG mode, the auto white balance setting may have given rise to images that appear "cold," exhibiting a blue color cast. The image may be "warmed" up selectively in a numerous ways, dependent on your level of experience. Using the Auto Color feature of Photoshop may give you the desired result, but there is more control if you opt for a manual adjustment. One of the simpler methods of achieving this is to create a separate adjustment layer and then increase the saturation of the image slightly.

STEP 7 CLONING

The cloning tool is one of the most useful tools for photographers and enables pixels from one part of an image (or even a different image in recent versions of Photoshop) to be transferred to another, thereby replacing unwanted elements within the scene or on the subject itself.

For instance, if a classic running shot of a dog is spoiled by some rogue twigs which have become attached to a dog's tail, the cloning tool offers a method of replacing the affected areas with fur from unaffected areas of the same tail. Cloning can be especially useful in outdoor scenes for manipulating foliage. It can be used to eliminate any patches of bright light visible through foliage or to remove any branches that might otherwise appear to be spearing an animal. They key to cloning is making sure the cloned part

does not look as though it is identifiable from the donor area, best achieves by switching from several source areas of similar potential.

STEP 8 SELECTIVE AREA CONTROL

A further step in your editing may be to selectively darken or lighten a proportion of an image. This may be to force the attention of the viewer to a selected part of an image for greater effect. A lighter proportion of the image may well be competing for the attention of the actual pet.

One way to achieving this is to use the Color Range tool, which allows you to select areas of a similar hue even though they may have complicated shapes like these leaves. It works by clicking on areas which are the shade you want to select, then showing you which will be selected in a black and white preview. You can also alt+click (⌥ + click on a Mac) to deselect a shade.

With the area selected, open the Levels tool. To darken the selected area, move the midtone slider to the right. To lighten the selected area, move the highlight slider to the left. Caution must be used when lightening selected area to ensure that detail is not lost.

STEP 9 APPLY AN EFFECT

The possible effects to your images are endless, especially if you include the many "plugin" applications you can buy to extend Photoshop's already generous feature set. Some of these so-called filters (they are not necessarily the same as traditional gel film filters) are more useful to photographers who want to perhaps enhance an image rather than dramatically change its appearance. A fast, but not necessarily the best, method of creating a sepia image uses this tool.

First open the Black and White tool from the menu and adjust the sliders until you have a monochrome image you are pleased with. Adjusting the sliders with this tool *does* have the effect film filters could, enhancing some tones over others. To take it at little further, open the Variations tool from the same menu. First select "More Yellow," followed by "More Red." Finally select OK and the changes will be applied.

Photoshop and other imaging tools offer far more than color changes through their filters though, and many of the options under that heading will irrevocably change the pixels of the image, so always be sure to work on a duplicate layer or duplicate image. Many of the effects are quite cheesy, but there are also tools to simulate film grain or to correct lens distortions which, as you get more familiar with Photoshop, will be well worth exploring.

STEP 10 CREATE A VIGNETTE

A final vignette to your image can draw the eye to the subject, especially for portraits where perhaps the pet has been centered in the frame. One simple method of creating a vignette is to use the rectangular marquee tool and draw a box a little way from the outer edge of your image, before applying a strong feather to it. Invert the selection (so the opposite pixels are selected). Be sure you are working on an empty layer at the top of your stack and create a black Solid Color layer (the selection will automatically mask it).

You can fine-tune the strength of your vignette by altering the layer's opacity. I find 25% to 50% to be a good range. If the "marching ants" are still on screen, deselect the selection so they don't affect your view. Of course creating vignettes is down to personal preference and the particular image in question. Some images will benefit from a vignette and on others it is best avoided. Use it sparingly as a creative tool.

STEP 11 FINISHING UP

Following your image processing, be sure to save the image under a different yet recognizable file name from the originally opened image. If you plan at any stage to continue working on an image, then ensure that it is saved somewhere as a TIFF file format rather than a JPEG. The final save to JPEG is only to be made when you have finished all of your editing and the next stage is to print the image.

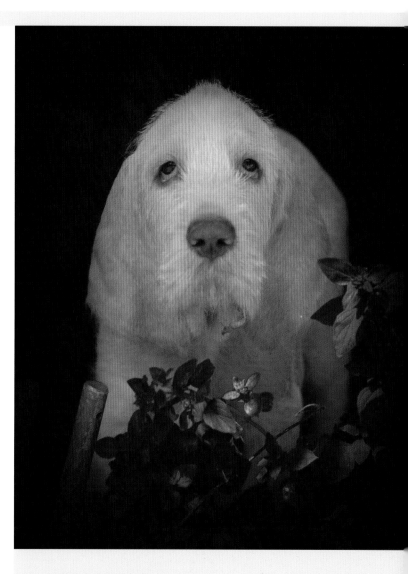

Above: Finished image's tone reflects the mood and character of the dog more than a simple color photograph would have. The other processing serves to draw the eye in on the subject—especially his face—and minimizes the distraction of the leaves in foreground.

Workflow (cont.)

The following sequence illustrates my approach to a different image. As always, any one photo can be worked in any number of ways to achieve an equally pleasing look, since these things are subjective. One image may look equally good in black-and-white as it does in color, for example. A close crop may also look great from an image that already looks good without being cropped. It is certainly worth to experiment at "working" an image in more than one way.

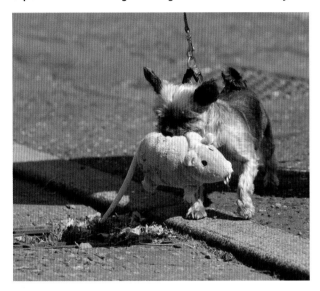

Above: In this second image, the exposure was slightly tweaked. It needed very little adjustment and just a slight refinement to increase the overall brightness. This has resulted in more detail being observed in the shadows that exist around the eyes and nose of the dog created from the "top" light of the midday sun. You'll also notice that the leash has now been cloned carefully away from the dog. The lead position meant that this stage of editing was very easy. This image has also benefited from being warmed up slightly by adding more proportions of red and yellow on a separate adjustment layer.

Top right: The original image, straight from the camera. The first thing to do is to look at the image and form a mental plan as to those areas you will address. Looking at this picture I propose to start by removing the lead, but I will also need to brighten up the area around the dog's eyes, as it has caught some shadow.

Above: After the more general brightening effect of a contrast adjustment, a more specific approach is used to finish the effect off. The dodge tool is used to gently lighten the shadow areas, set at a low opacity so the effect is controlled. This can help enhance a small catchlight, too.

Opposite: A slight degree of Gaussian Blur has been added to the whole image on a separate layer and, using the Eraser tool, the sharpness of the dog holding its toy rat was carefully brought back by selectively erasing through the layer with the blur. A simple vignette was then added around the edges of the image.

Physical display options

The display options for your pet images have never been greater with numerous choices and finishing styles for a truly remarkable look. As with any photography it's important to display your work to its maximum potential. Your house may not have the space to house a 6 foot by 4 foot (1.8 by 1.2 m) canvas, but there exists an ever growing variety of different choices for different tastes. This choice extends to surface finish, and papers are available with conventional gloss and matt, as well as more specialist options like metallic, acrylic, satin, canvas, or even leather.

There also exists a wide range of frame options to add an extra dimension to your finished product and showcase your work.

From classical single framed photographs through to multi-aperture products, the choices are numerous. There are still the cheaper products on the market such as the clip frames, for those with a limited budget, but there's no mistaking the look of a superbly mounted and framed print. When all the trouble and hard work has gone into crafting that fine photograph of your chosen

pet it seems a great shame for the resulting presentation to be sub-standard. Clients, too, will pay for good presentation.

So what are the options for you to consider for both your image and choice of product? Below is a list of just some of the more popular products on the market today.

If an image is not particularly sharp, the blur is only going to be exaggerated when enlarged

SINGLE IMAGE PRODUCT

A single image product will gain the full attention of its viewers without other images competing for attention in the same frame. Some images will look better smaller (surrounded by a larger mount) than a large image with a smaller mount surround. After editing, if the final chosen crop of the image results in a small

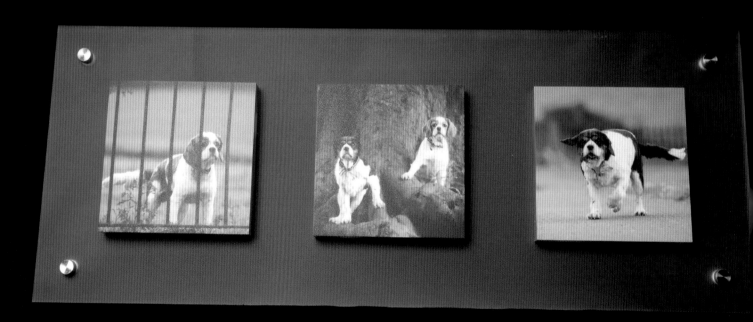

image, or perhaps the image sharpness is not great, then a smaller image with a larger mount surround may be the preferred option.

Another consideration is the choice of frame and mount surround. Does it complement the image or detract from it? Will it work in the surroundings in which it is to be displayed? Does this matter, or should the furnishings be changed to match your stunning image?

MULTI-IMAGE PRODUCTS

This simply refers to a frame or product that is designed to house more than one image. These works well with a series of images, like a dog in pursuit of a flying ball, a dog mid-jump catching the ball, followed by the dog landing with ball. A multi-image product may also comprise one larger image complemented by a few smaller images. The trick for any multi-image product is that the images must complement each other. You may have three brilliant images but when they are placed along side each other in the same frame, they do not like quite as appealing. Use the rules of color and positional composition that you would in an individual image across the whole product.

ACRYLICS

The image is sandwiched between acrylics giving a three dimensional, contemporary appearance. Acrylic products, like the framed products, can house more than one image, to either show a sequence of shots or different perspectives of a pet.

CANVAS PRINTS

Here the image is printed directly onto canvas. The image can also be wrapped around a wooden frame stretcher, thereby extending the image's viewable area beyond just the front face. You will need to ensure that there is enough space in the scene around the actual pet since the act of attaching the canvas print to the frame effectively crops the image by the width of the wooden beams.

SPECIALITY METALLIC PRINTS

In this technique the image may be printed onto high grade inkjet paper such as a "giclée print," and then sealed with a metallic laminate. It can then be mounted onto a rigid aluminium panel. There are many suppliers now offering metallic prints as part of their extensive range.

OTHERS

I'm always amazed at the range of products that continually appear in the market place, allowing you to display your chosen images in all kinds of environments. This exhaustive list can include anything from cushion covers, bags, jigsaws, key rings, chopping boards, table place mats, mugs, mouse mats, and t-shirts to name just a few! It must be said, that the maximum size of your chosen image may actually be limited by the actual quality of the image itself. For example, if an image is not particularly sharp, then such a fault is only going to be exaggerated and remain visible if the image's dimensions are increased or interpolated upwards.

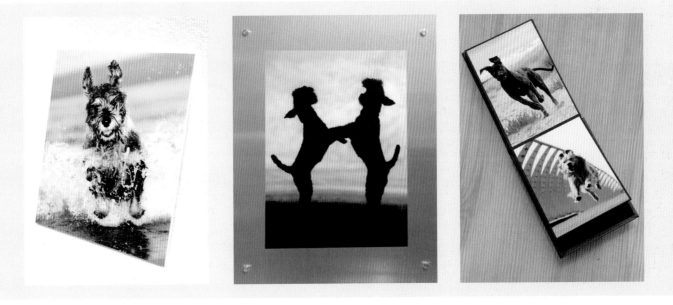

Digital display

Aside from physical products to showcase your images, DVD slideshows, Web orientated slideshows, and photo sharing websites have gained in popularity over recent years. The key advantage of this electronic sharing methodology is that they can easily be shared amongst friends and relatives, locally and across the world in a matter of minutes. Many of the image editing applications, such as Breeze Browser, Adobe Lightroom, or iViewMedia Pro, have built in web gallery features that do all the hard work of constructing and uploading web pages of your images for you. All you need to do is provide the server address.

Slideshow software applications are also numerous, enabling viewing directly on your computer, while others (like Photoshop Elements or iDVD) make it possible to burn the images to a disc and watch them using a domestic DVD player.

The last few years have also seen a rise in photo-sharing websites that do not require you to purchase specific software, and perhaps the best known is Flickr. Your images can be uploaded via the website's own interface and you can share images with interested parties, whether they are friends or potential clients.

Digital photo frames are also rapidly appearing in the market place and are available in various sizes and with different mouldings/finishes. These products are by default set to show a series of images over a designated period of time, thereby keeping the interest of the viewer as the image changes at the set interval of time, usually a few seconds. They will allow you to simply insert a media card from a camera and view the JPEGs without the need for a computer, though you could always write to the memory card from your computer if you have the necessary equipment.

Portable music players such as iPods and mobile phones are also increasingly being used to share images with friends and family and in the case of phones—which offer email and multimedia messaging—can often be sent to friends and relatives as well as shown onscreen to those around you.

The digital revolution has certainly not come to a stop yet, and as electronic displays become ever more pervasive it will get easier and easier to show digital images. Where will it end?

Will refrigerators feature a photo frame in the future? Believe it or not there are already some designs out there. The important aspect for me is that the images on those displays are meaningful and evoke a positive response and smile from as many as possible, whether they're an agile handler, or elderly individual, no longer able to care for a pet of their own, but not lacking in love for them.

Above: Apple's iPhoto, in common with many similar programs for all computer platforms, has a play button which will instantly start showing your selected pictures as a slideshow.

Above: Flickr is a useful tool, not only as a photo-sharing website that allows you to get involved in the community, but from a private perspective too. You can choose to keep your images private, but they will still be stored remotely from your machine, which make it an effective last resort backup system.

Above: Digital Photo Frames are a popular way to view photos.

Left: Portable digital devices like the Apple iPhone are starting to have larger and larger displays, making them great ways to carry around images and show them on the go.

Top 10 tips for improved pet photography

1. Understand exposure and learn how it can be manipulated using your camera's settings to control shutter speed and depth of field.

2. Research your pets and any breed profiles to gain a better understanding of the animal behavior characteristics.

3. Critically explore the available locations for pet photography in advance of the shoot and visualize the pet in the scene.

4. Examine the lighting present within any environment and note its direction, strength, and quality.

5. Ensure that you take into consideration the health, safety, and welfare of yourself, the handler, and the pets.

6. Ensure that the pets being photographed are well groomed and that the eyes are clearly visible.

7. When photographing outdoors pick your time of day carefully and avoid the midday sun or "top" light if at all possible.

8. Don't wear your best clothes and be prepared to spend a lot of time lying on your stomach.

9. Ask the owner about the pet and determine if the pet has any quirky pet traits that may be worth attempting to capture.

10. Don't be afraid to experiment and make different compositions than those you may have seen before. You'll develop your creativity and other ideas will stem from your initial attempts.

Index

A

accessories 9, 62
acrylics 120–21
action shots 11, 41, 59, 80–83, 91–92, 98, 105
Actions 111, 116
adjustment layers 115
Adjustments 116
Adobe 61, 110–11, 114
advertisements 60
ailments/afflictions 24, 40
angle of sun 29
angle of view 52, 64–66, 71
aperture 6, 11–12, 14, 50–52, 55, 59, 70, 83, 91, 106
artificial lighting 18, 43, 55, 6163, 70
aspect ratio 115
assistants 42, 89, 100, 104
attention-grabbers 20, 49, 57, 100
Auto Color 115

B

back-lighting 58–59, 66
back-up 16, 109, 114
background 19, 26, 41–43, 48, 52, 62, 66, 72, 78, 82, 91–92, 103–4, 106
bags 121
batch processing 111
batteries 37
beaches 29, 34, 41, 49, 80, 104
behavior 6, 24, 26–27, 30, 34–35, 44, 49, 69, 74, 90
birds 98, 106–7
black pets 84, 87
black-and-white 71, 114, 116
Blu-Ray writers 16
body language 20, 69
books see reference books
bounced flash 62, 91
breed profiles 24, 49, 60, 76, 104
bribes 96
Bridge 114
brightness 59
budgerigars 106
build quality 10–11
burn out 84
butterflies 98

C

caged pets 14, 40, 64, 103, 106
calibration 111–12
camera bags 90

camera shake 12
camera-to-subject distance 14–15, 55, 70, 89
cameras 10–13
Canon 15
canvas 120–21
capabilities 10
catch lights 26, 62, 66, 76
catnip 92
cats 6–7, 12, 14, 20, 24, 26–27, 30, 32–33, 38, 40–41, 43, 47–49, 52, 56, 59–60, 64, 69, 90–102
CD discs 114
center-weighted metering 11
characteristics 24, 26, 30, 35, 59–61, 64, 69, 80, 82
chest waders 34
children 24, 34, 102
chopping boards 121
clients 30, 49
clip frames 120
cloning 115
close-ups 10, 14, 19, 105
clouds 28, 55
cockatiels 106
coding 114
cold colors 115
color casts 62, 115
color correction 111, 115
color curves 115
color management 112
color markings 26, 43, 58, 66, 72, 84–87, 94
color temperature 55
commercial shots 19
compacts 10–13, 50–51, 55, 62, 110
composition 12, 43, 50, 66, 69, 86–88, 100, 103, 110, 114
compression 12, 114
computers 12, 16–17, 112, 114
context 76
continuous light sources 62
continuous servo 11, 82
contrast 62, 110–11, 114
conversion 111, 114, 116
converters 14
creative shots 61, 104
cropping 12, 111, 115, 120
CRT (cathode-ray tube) monitors 112
cushion covers 121

D

darkening 116
default values 117
deleting 114

depth of field 50, 52, 55, 59, 70, 88, 91, 106
Desaturate 116
deselection 117
detail 12–13, 51, 60, 69, 84, 87, 114–16
development timeline 114
diets 20
diffused flash 91
diffusers 63
disabilities 24
display options 7, 109, 120–21
distractions 27, 41–43, 48, 59, 72, 76, 84, 88, 91, 104, 115
dogs 6–7, 10–12, 14–15, 20, 22, 24, 26–30, 32–34, 38, 40–41, 44, 48–49, 52, 55–57, 59–60, 64, 69–89, 102, 115, 121
duplicate layers 116
dust 28, 34
DVD writers 16, 114

E

ears 76, 78
Edit menu 117
Effects 116
electrical shutter notification 13
enlargements 120
equipment 7, 9–10, 35, 37, 42, 51
event shots 58–60, 105
EXIF data 52
exposure 11–12, 41, 43, 50–52, 78, 83–84, 86–87, 96, 100, 103, 110–11, 114–15
exposure compensation 18, 50, 84
exposure correction 114
external hard drives 16, 114
eye contact 38
eye discoloration 18
eyes 13, 26, 29, 32, 38, 55, 61–62, 72, 76, 80, 88, 91, 94, 106, 112

F

f stops 52, 55, 84
facial details 10, 14, 80, 102
feathering 116–17
file formats 12, 111, 114, 117
file names 117
Fill 117
Filter menu 116
finishes 120
fish-eye 14, 61
Flach, Tim 61
flash 18, 62–63, 91, 105–6
fluorescent light 55
focal length 12, 14, 52, 55, 89

Index

focal length multiplier 15
focusing 10–11
folders 114
foliage 115
food 20, 38, 44, 46, 48, 56, 78, 88, 98, 103, 105
frame stretchers 121
framing 102–3, 120
freezing motion 11, 50–52, 62, 82–83, 91
front lighting 61, 66
full frame 15
full length 19, 72, 105
furry pets 102–3

G

galloping 105
gerbils 103
giclee prints 121
glossy prints 120
Gobos 84
golden light 28
goldfish 48
greeting pets 38
groomers 33
grooming 32–33, 104
group shots 7, 14, 22, 38, 46, 59, 66, 80, 86–89, 100
Groves, Lesli 104
guinea pigs 14, 20, 27, 38, 46, 102

H

halogen 18, 55
hamsters 43, 59, 103
hand signals 20
hand-held shots 15, 52, 62, 78
handlers 20, 24, 34–35, 38, 41–44, 49, 56–61, 63, 70–74, 78, 80, 82, 86, 88–91, 100
handling 10–11
hard disk space 16
hard light 18, 62
hardware 16–17
harnesses 74
hazards 43
head shots 105
head-and-shoulders 7, 19, 32, 72
heat 19, 96
heat lamps 70
hiding places 90, 102
highlights 84, 116
histogram data 114
homework 24–27, 91
horses 20, 24, 26, 29–30, 40–41, 51–52, 58–60, 63, 69, 104–5

hot shoe 62
hot water bottles 96
hues 115
hunting 98

I

Image Menu 116
image quality 70, 112, 115, 121
image selection 114
image size 121
indoor shots 7, 19, 28, 42–43, 55, 80, 91, 96, 102
inkjet paper 121
inkjet printers 112
Internet 24
interpolation 121
intuitiveness 10–11
Invert Selection 117
ISO settings 6, 11–12, 15, 50–52, 62, 70, 83, 91

J

jigsaws 121
JPEG files 12, 111, 114–15, 117

K

Kelvin scale 55
key rings 121
kittens 90–94, 96, 98

L

laminates 121
large prints 12
Lasso tool 116
layers 114–16
LCD (liquid crystal display) monitors 112
LCD (liquid crystal display) screens 6, 10, 117
learning exercises 114
leash-holding shots 74–75
leather effect finishes 120
legs 76, 83, 105, 114
lenses 10, 12–15, 52, 55, 58, 61, 70, 78, 89, 91, 106
Levels 116
life-cycles 26
light spheres 63
lightening 116
lighting 10, 18–19, 28–29, 41–43, 48, 50–52, 55–56, 58–63, 66–67, 70–72, 78, 82, 84, 86–87, 91–92, 96, 103–4, 106, 112
locations 9, 24, 27–28, 30, 34–35, 40–43, 50, 58, 61, 72, 82, 88, 96, 98, 104

lossy compression 12, 114
low light 10–12, 14, 29, 42, 52, 78, 91

M

macro 10, 13–14
magical shooting time 50
manuals 51
manufacturers 10, 112
matrix metering 11
matt prints 120
memory cards 9, 38, 109
menu systems 110, 116
metallic prints 120–21
metering 11, 84
mice 61, 94
mindset approach 6
mobile phones 91–92
Monaco EZ 112
monitors 16, 111–12
Morris, Desmond 24
motion blur 12, 51–52
mounting 120–21
mouse mats 121
movement 7, 10–11, 46, 52, 73, 83, 91, 102
mugs 121
multi-image products 121

N

natural lighting 18–19, 43, 55, 61, 70
neutral target 71
night vision 18
Nikon 15
noise 12, 15, 20, 48, 52, 56, 71, 78, 88, 94, 100
non-full frame 15
non-lossy compression 114

O

obedient pets 48, 73, 80, 88–89
on-camera flash 62
opacity values 117
outdoor shots 7, 18, 34, 40–43, 55, 72, 80, 88, 96, 98, 102, 104, 115
output 110–11
overexposure 50–52
overhead lighting 58
overweight pets 82

P

panning 52, 83
paper 121

parrots 106
patting 20, 38
PCs 117
pedigree profiles 30
perched birds 106
Photoshop 7, 61, 110–12, 115–17
planning 7, 9, 24–27, 34–35, 40
ponies 104–5
post processing 7, 12, 32, 56, 71, 74, 89, 109–21
preparation 24–27, 37, 44, 109
previews 114
printers 112
prints 109, 112, 117, 120–21
profiles 24, 30, 49, 60, 72, 76, 104–6
props 7, 9, 22–24, 61, 76, 86–87, 103
prosumers 11–13, 55, 110
psychology 24, 48
puppies 70–71, 89–91

Q

quirky shots 61, 82, 92, 114

R

rabbits 6, 14, 24, 26–27, 30, 44, 102
radiators 96
radius values 116–17
rainproofing 10
RAM (Random Access Memory) 16
rats 48
Raw files 12, 16, 114
record shots 59, 70
Rectangular Marquee 117
red-eye 18
reference books 24, 60, 111–12
reflectance value 84
reflections 29, 41
rescue pets 6, 24, 38, 63, 86
research 24, 88
resolution 12
retractable wire leashes 74
riders 104–5
rim-lighting 29, 59, 66
rodents 24, 40
Rule of Thirds 115
running shots 82–83, 114–15

S

safety 7, 34–35, 57, 80
satin finishes 120
saturation 110, 115
saving images 114, 117

search engines 116
sedation 33
Select menu 116–17
Selective Area Control 116
self-ruling pets 43, 48–49, 70, 88
semi-obedient pets 48–49, 88
sensors 11–12, 15, 51–52
sepia tones 116
sets 22–23, 59, 92, 103
shadows 84
sharpness 50, 55, 70, 88, 106, 110–11, 120–21
shoe laces 70–71
shooting data 114
short listing 114
shutter lag 11
shutter speed 6, 11–12, 41, 50–52, 55, 58, 62, 70–71, 82–83, 91
shutter speeds table 52, 82
side-lighting 58, 61, 66
Sigma 14
silhouettes 29, 59, 66
single image products 120–21
skies 41
sleeping pets 14, 52, 70–71, 90–91, 94, 100
sliders 114, 116
SLRs 10–15, 50–52, 55, 62, 78, 110
soft boxes 63
soft light 62
software 12, 16, 49, 73, 110–12, 114
sounds 88
speciality metallic prints 121
sports mode 11
sports shots 58
spot metering 11
stabilizing systems 15
stalking 49, 98
stallions 105
start-up times 10
Stofen 63
stroking 20, 100
studio shots 30, 59, 61, 72, 88
studio flash 18–19
sunrise 28–29
sunset 29
surface finish 120

T

t-shirts 121
table place mats 121
tactics 71, 96
tagging 114
tank housings 10
tapetum 18

telephoto 58
temperament 24, 26–27, 37, 44, 89, 91, 100
test shots 43, 50, 70, 84, 96, 114
texture 41, 46, 66, 86
three-dimensional appearance 121
tide 29
TIFF files 111, 114, 117
timing 28–29, 58
Tokina 14
tones 115
tongues 72
top light 84
tortoises 10–11, 30
toys 56, 76, 90–92, 100
tracking 10
treats 20, 38, 48, 56, 78, 98, 105
tricks 61
triggers 24
tripods 106
tungsten 18, 55
typical frames 120–21

U

underexposure 50–52, 84

V

Variations 116
viewfinders 12, 76, 102
viewing conditions 112
vignettes 117
Vista 16

W

warm colors 115
water 29, 34, 41, 44, 59, 83
waterproofing 10, 34, 64, 70
web images 109
welfare 7, 34–35, 63, 71, 80, 106
white balance 12, 43, 55, 71, 115
white pets 84, 87
wide-angle 7, 14, 61, 70
Windows 16
windows of opportunity 78
workflow 16, 111, 114–19

Z

zoom 10, 14, 70, 80, 89
zoom magnification 12

cknowledgments

This book would never have been completed without the wonderful pets that I have had the privilege to photograph over the years, not to mention their patient and enthusiastic owners! The support and encouragement of my wife, Kathryn is also acknowledged as well as that of our immediate families. They have played a tremendous role in helping us care for our two young boys, Euan and Kieran, during the writing of this publication. To Euan and Kieran especially, don't be afraid to follow your dreams throughout life, especially in the face of adversity. All you need is self belief especially when all others truly doubt you. Thanks also to Sheila at the Carrick Veterinary Centre. Lastly, a note of thanks to Adam (my Editor) for his patience and professionalism over the last six months and helping to keep the ship from the rocks!

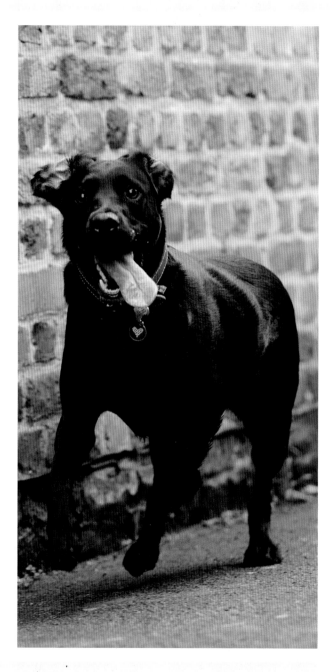

USEFUL WEBSITES
www.pawspetphotography.co.uk
My own personal website that is regularly updated and shows a multitude of different pet pictures.

www.photoshoptv.com
A great resource for exploring in depth the capability of Adobe Photoshop.

www.dpreview.com
One of the most comprehensive websites for detailing reviews of digital camera equipment, both old and new.

www.loxleycolour.com
Professional photo lab providing a vast array of different products in addition to prints.

www.photoartistry.co.uk
One company providing an excellent array of different choices of products for displaying your images.